IMAGES
of America

BRENTWOOD

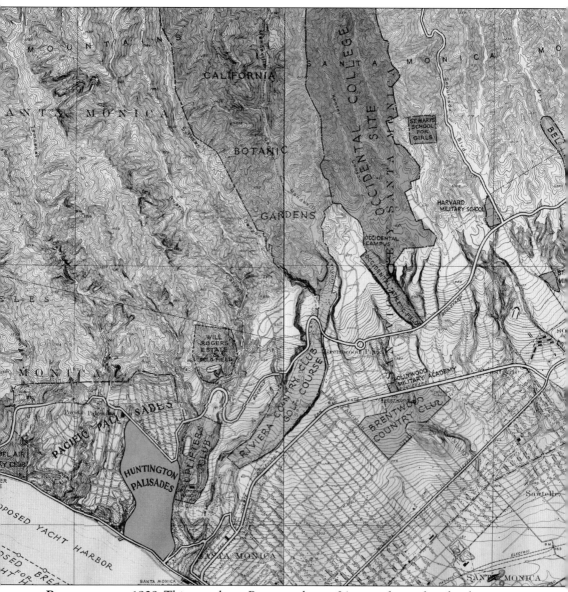

BRENTWOOD IN 1929. This map shows Brentwood some 24 years after its first developments were laid out. San Vicente Boulevard is a clear landmark. The California Botanic Garden is noted as is the proposed Occidental College site. This detail was taken from a brochure that was used to advertise new developments in Pacific Palisades. (Courtesy of the Santa Monica Land and Water Company Archives.)

ON THE COVER: GRADING BUNDY DRIVE. In 1905, workers using teams of mules and horses take a break to pose for the camera near Montana Avenue. Houses are beginning to rise along San Vicente Boulevard in the background. Lawrence Duncan Loomis, one of the developers of Westgate is seated on the right hand side of the photograph. (Courtesy of the Santa Monica Land and Water Company Archives.)

IMAGES
of America

BRENTWOOD

Jan Loomis

ARCADIA
PUBLISHING

Published by Arcadia Publishing
Charleston SC, Chicago IL, Portsmouth NH, San Francisco CA

Printed in the United States of America

Library of Congress Catalog Card Number: 2007936585

For all general information contact Arcadia Publishing at:
Telephone 843-853-2070
Fax 843-853-0044
E-mail sales@arcadiapublishing.com
For customer service and orders:
Toll-Free 1-888-313-2665

Visit us on the Internet at www.arcadiapublishing.com

*This book is for Adelaide Gillis McCormick and Dorothy Gillis Loomis
(my husband's aunt and grandmother), who lived these stories during
their nearly 100 years and told them to us. It is a small effort to make
their memories available to those who live in Brentwood now and
to those who will live there in the future. Enjoy their stories and the
photographs that illustrate them as much as they did, and we did.*

CONTENTS

ACKNOWLEDGMENTS

This book started over 25 years ago when I first became aware of the records stored in the Santa Monica Land and Water Company offices. Thanks to Lois Flagg, the longtime secretary of the company, a treasure trove of photographs, maps, correspondence, legal documents, and other ephemera was preserved in the company vaults. Studying these records led to numerous questions that were patiently answered by Flagg, Dorothy Gillis Loomis, Adelaide Gillis McCormick, Frances McCormick Armstrong, and Margaret Ynez Loomis. In addition to these fascinating individuals, I talked to anyone else I could find whose memory included the early days of West Los Angeles and was still alive in the early 1980s.

These invaluable conversations and resources have been the genesis for a number of articles and books about West Los Angeles—its beginnings and its growth. This book is an extension of that research. I would also like to thank the Brentwood Historical Society—Laura Blumenthal, Delores McKenney, and Gloria Smith—for their assistance and patience. They have provided answers, contacts, endless photograph scanning, and support. I will be forever grateful. My thanks to the archivists at the University of Southern California Libraries, the Santa Monica Public Library, the Los Angeles Public Library, and the Charles E. Young Research Library, UCLA for their input and assistance. Many thanks to the numerous Brentwood residents who have opened their collections and their memories to make this book possible. Finally, my heartfelt thanks to my husband for his patient research, his scanning skills, and most of all his unswerving support. This book could not have made it to press without him.

INTRODUCTION

The first human inhabitants of the Brentwood, Los Angeles, area were the Gabrielino Tongva Indians who roamed the Los Angeles basin. The Kuruvungna Springs site at University High School in West Los Angeles was once a thriving Native American village (pictured on the following page). Grinding stones were often turned up by early residents, along with pottery shards and other bits and pieces, reminders of these early settlers.

Spanish explorers—including Fr. Juan Crespi, the diarist of the group—traveling from the Los Angeles Pueblo to Northern California rested near these tear-shaped pools and named them Las Legrimes de Santa Monica after the tears of the mother of St. Augustine. This story is possibly apocryphal, since Crespi's diary calls the springs El Berrendo after a wounded animal.

Later the canyons, rolling mesas and hills of Brentwood, Los Angeles, became part of the Rancho San Vicente y Santa Monica granted to the Sepulveda family. In 1872, the Sepulvedas sold the bulk of the property to Col. Robert S. Baker for about a $1.50 an acre. Baker grazed sheep on the grassy pastureland but also began to sell off chunks to various entrepreneurs. Baker married the beautiful Arcadia Bandini de Stearns, one of the wealthiest women in Los Angeles, in 1875.

Nevada senator John Percival Jones bought two-thirds of the original rancho and with Baker's help subdivided the town of Santa Monica in 1875 from their joint holdings. In 1887, Baker deeded the remainder of his rancho land to his wife. In 1887, real estate was no longer booming, and the area was still open land. Bandini and Jones needed a way to reverse the trend and promote their land as a place to live.

Fortunately, at about the same time that the real estate downturn occurred, Congress authorized the Board of Managers of the National Home for Disabled Volunteer Soldiers' to locate a site west of the Rockies as a home for Civil War veterans. The lure of the $250,000 annual federal budget and the $66,000 in annual pensions that would be spent in the vicinity of the new home was enough to generate offers for 61 sites. Bandini, Jones, and the owners of the Wolfskill tract offered 300 acres each along with land for water storage and some money. Their site was number 59 on the list.

The Board of Managers was undecided and seriously considered turning all the sites down. However, Jones's attorney sent a telegram to their meeting in San Francisco offering $50,000 cash in addition to the land. The cash turned the day, and the board accepted the Baker/Jones/Wolfskill proposal. The Pacific Branch of the National Home for Disabled Soldiers' would be located on their land, thus ensuring them of a steady source of new residents and a hefty government payroll that could be spent in their neck of the woods.

The facility opened with its first patient sign-in in 1888, and soon there were over a 1,000 residents living in the newly completed buildings. The gracious Victorian buildings were a popular excursion destination for Angelenos and many a family posed for pictures on its wide verandas. Gradually a small settlement of homes and services began to grow up around the south end of the grounds—bordered by Ohio, Pico, Federal, and Veteran Avenues. Originally the area was named Barrett Villa after General Barrett, head of the Soldiers' Home, but postal authorities rejected that name as too close to Bassett, California. The village was rechristened Sawtelle on July 4, 1899, named for banker and developer William E. Sawtelle. Lots cost from $80 to $100 and were sold to veterans who could live on their own, to their families, and to employees. A

business district grew up to service the residents along Fourth Street (now Sawtelle Boulevard). The Sawtelle area was incorporated in 1906 as a city but was annexed to Los Angeles in 1922, drawn by the promise of a steady water source from the new Los Angeles aqueduct.

Robert Conran Gillis was related to W. E. Sawtelle by marriage. By 1905, he was also the owner of the Santa Monica Land and Water Company—the corporation formed by Baker and Jones to hold their Rancho San Vicente acres. As such, he owned much of the land surrounding the Soldiers' Home. Gillis began to subdivide the land outside the west gate of the Soldiers' Home into lots for a community he called Westgate. These lots sold for $150 with some larger lots costing $350. (Real estate was already appreciating at a good rate.) San Vicente Boulevard, with its trolley tracks down the median, connected the area to the rest of Los Angeles. Other developments followed—Westgate Acres, Westgate Gardens, and Westgate Heights.

In 1906, the Western Pacific Development Company bought 360 acres from the Santa Monica Land and Water Company and began laying out Brentwood Park, naming it for William Lynton Brent. Brent was the president of the Merchants Trust Company and was one of the investors in the development. The hype for Brentwood Park included promises to hire John McLaren, the landscape gardener responsible for Golden Gate Park, to turn the area into a parklike environment. The claim was that 100,000 trees would be purchased for a cost of a half million dollars. By 1916, lots were selling for $3,000. Brentwood Park was laid out with wide streets and a number of traffic circles. Its influence on the rest of the area was such that gradually, over the next 30 years, the entire area became known as Brentwood.

The entire Brentwood area was annexed to Los Angeles in 1916, lured by access to the newly completed aqueduct and an unlimited water supply.

Over the next 100 years, more neighborhoods were developed, and Brentwood became an affluent suburb of Los Angeles, known for its beautiful homes, its many movie star residents, and its relaxed lifestyle. The Soldiers' Home became the Veterans Administration West Los Angeles Healthcare Center; the small homes along San Vicente Boulevard became shops and commercial buildings; the trolley tracks gave way to coral trees; and the real estate prices continued to climb. The Getty Center and Skirball Cultural Center opened and the I-405 now roars through the community. Past, present, and future—Brentwood thrives.

One

THE RANCHO
THE WAY IT WAS

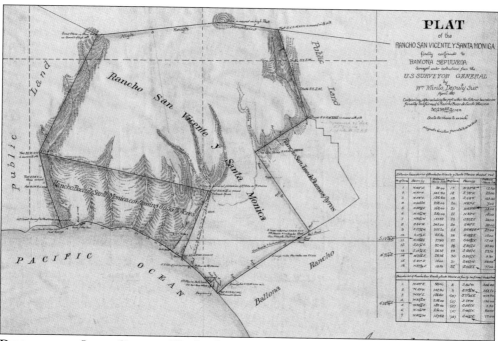

DEFINING THE LAND GRANTS. The land that became Brentwood was part of a Mexican land grant made in 1828 to Don Francisco Sepulveda. The boundaries of the land grant are shown on this plat map made in 1881 as part of the settlement of a long running dispute over the boundaries of the original grant. The map shows the three large holdings that became today's West Los Angeles—the Rancho San Jose Buenos Ayres, Rancho San Vicente y Santa Monica, and the Rancho Boca de Santa Monica. Brentwood and Santa Monica were carved from the Sepulveda property while Westwood and Pacific Palisades were created on the other two ranchos. (Courtesy of the Santa Monica Land and Water Company Archives.)

MESA AND CANYON LAND. The Rancho San Vicente y Santa Monica was open land used for growing hay and barley in the 1800s. It was cooled by ocean breezes and morning fogs. Oaks and sycamores grew along the waterways. The Californios grazed cattle on the land and did a brisk trade in hides and tallow. Los Angeles was a long, dusty, day's ride away. (Courtesy of the Santa Monica Land and Water Company Archives.)

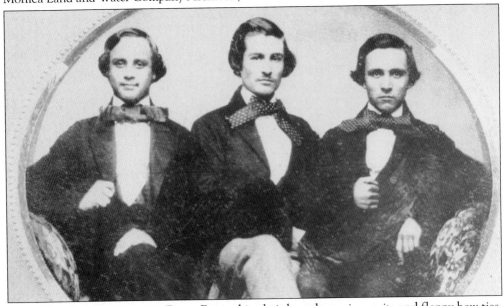

THE SEPULVEDA GRANDSONS POSE. Dressed in their best three-piece suits and floppy bow ties, Ygnacio (left) and Andronico Sepulveda (right), flanking Antonio Yorba, gaze solemnly at the camera in this 1850 image taken before they left for school in Boston. The Sepulveda brothers were the grandsons of Francisco Sepulveda, the original owner of the Rancho San Vicente y Santa Monica. (Courtesy of the University of Southern California, on behalf of the USC Special Collections.)

SEPULVEDA ADOBE IN 1933. The Casa de Don Dolores Sepulveda was in ruins by 1933, with its adobe walls crumbling and its roof falling in. Don Dolores was the son of Francisco Sepulveda. The building was located on South Bundy Drive below Santa Monica Boulevard, and it no longer exists. (Courtesy of the University of Southern California, on behalf of the USC Special Collections.)

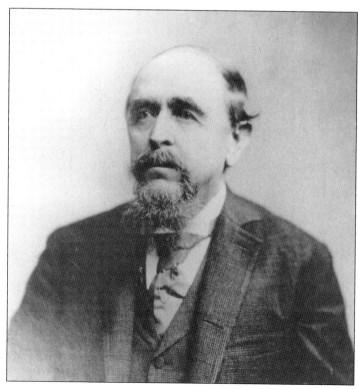

THE NEXT OWNER. Col. Robert Symington Baker was born in Rhode Island in 1822 and made a fortune as a merchant in San Francisco during the Gold Rush. The price of wool was high in the 1870s, and Baker needed land to graze sheep. In 1872, he purchased the 30,000-acre Rancho San Vicente y Santa Monica from the Sepulveda heirs for $55,000. (Courtesy of the Security Pacific Collection/Los Angeles Public Library.)

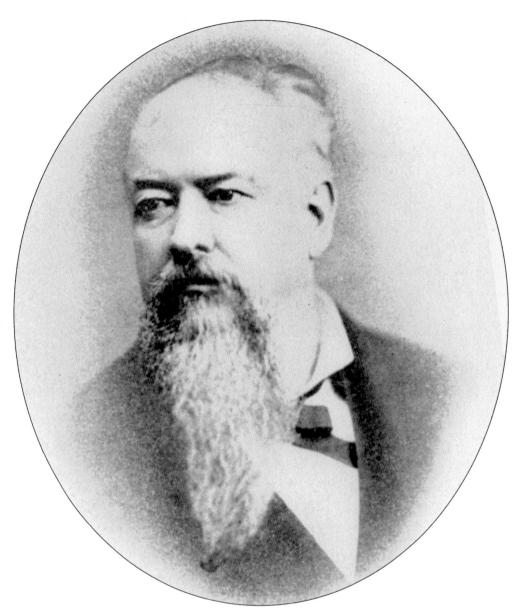

SILVER AND SHIPPING. John Percival Jones was born in Great Britain in 1829 and emigrated to the United States as a child. He came to California as a forty-niner and struck it really rich in the Comstock Lode near Virginia City, Nevada. He was elected to the United States Senate in 1873—one of the millionaire senators from the West. Jones wanted to ship his silver more quickly than the slow mule teams that were the transportation of the day—he wanted a railroad to a port. In the meantime, Baker was planning an expansion of the small landing located on his land at Santa Monica Bay and adding a railroad. In 1874, Jones partnered with Baker and bought substantial holdings in both his land and his railroad plans. Together they launched the town of Santa Monica with a successful land auction on July 15, 1875. Santa Monica was successful, but the port and railroad never quite made it. (Courtesy of the Santa Monica Public Library Image Archives.)

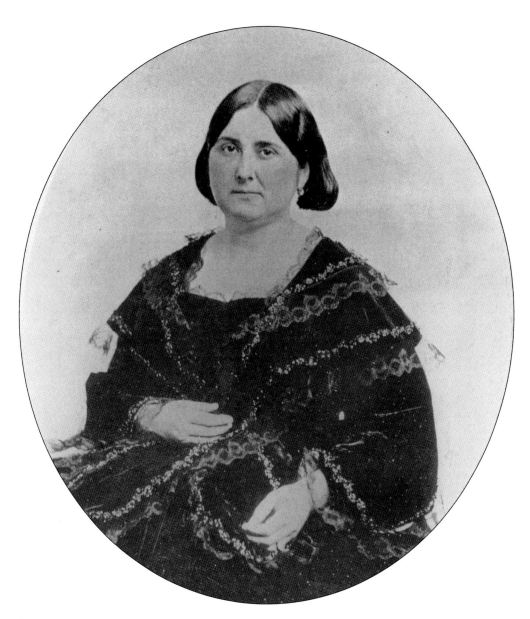

CALIFORNIA BELLE. Arcadia Bandini de Stearns was widowed suddenly in 1871 when her husband, Don Abel Stearns, died in San Francisco. Wealthy and only in her mid-40s, she was popular in Los Angeles society. In 1875, she married Baker, thus combining their two fortunes. Baker's ambitious plans landed him in debt and in order to preserve his options, he deeded his remaining Rancho San Vicente property to his wife in 1879. The Baker's built a comfortable home in Santa Monica on the bluff overlooking the ocean and split their time between that house and their elegant apartment in the Baker Block in Los Angeles. After Baker's death in 1894, Arcadia and John Percival Jones stayed in business together for a number of years finally forming the Santa Monica Land and Water Company in 1897 and putting into it all of their land holdings. Arcadia continued to work with Senator Jones until the sale of the Santa Monica Land and Water Company in 1905. (Courtesy of the Security Pacific Collection/Los Angeles Public Library.)

JUANITO, THE MANAGER. Juan Bautista Antonio de Padua Bandini, known as Juanito to distinguish him from his father, also Juan Bandini, was the brother of Arcadia Bandini de Baker. This picture was taken in his sister's garden in Santa Monica in 1901. He managed her affairs and was on the board of the Santa Monica Land and Water Company for many years. (Courtesy of the Santa Monica Public Library Image Archives.)

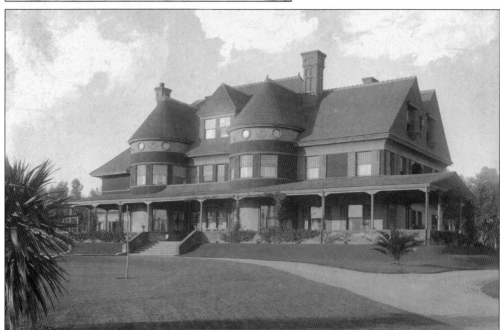

SENATOR JONES'S HOME, MIRAMAR. Located on Ocean Avenue in Santa Monica, John Percival Jones built this home in 1899. Jones often entertained the investors, developers, and businessmen of the day at the house, regaling them with stories about his exploits during the Gold Rush. He served 30 years in the United States Senate. The house site was eventually converted into the Miramar Hotel. (Courtesy of the University of Southern California, on behalf of the USC Special Collections.)

Two

THE OLD SOLDIERS' HOME

ANCHORING A COMMUNITY

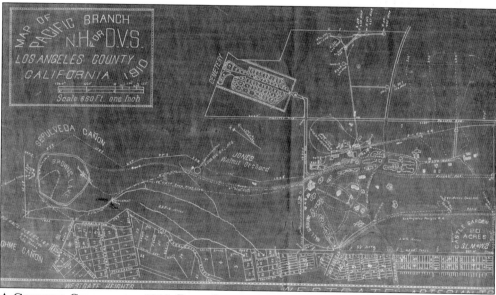

A GROWING COMMUNITY, 1910. Even after starting Santa Monica, Senator Jones and Arcadia Bandini de Baker owned a great deal of vacant land. Real estate sales had slumped, and they needed a way to attract residents to buy lots and build homes. So, it must have seemed providential when Congress appropriated money to find a site west of the Rockies for a National Home for Disabled Volunteer Soldiers. This home would house Civil War veterans living in the western states and would add a $250,000 government payroll to the area selected. Jones and Baker—as the deed states—gave the 300-acre site "to locate, establish, construct and permanently maintain such a branch of said National Home for Disabled Volunteer Soldiers" in 1887 according to the deed. Another 300 acres was donated from the Wolfskill tract. The board selected their gift and the first patient mustered in on May 2, 1888. By 1910, the Soldiers' Home, as it was known then, was bringing residents, commerce, and prosperity to the Rancho San Vicente. (Courtesy of the Santa Monica Land and Water Company Archives.)

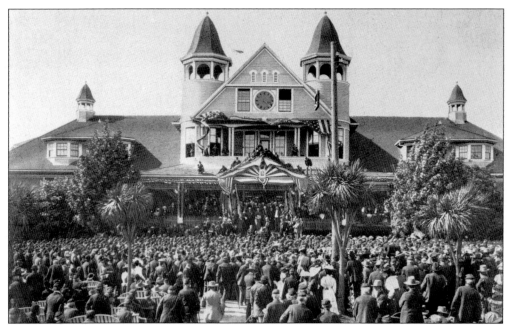

President McKinley Visits, 1901. The dining hall steps of the Soldiers' Home were often used as a reviewing stand for dignitaries in the early days of the facility. President McKinley drew a large crowd on May 9, when he was brought by private trolley car to the site for a reception and speech. Attendees were saddened when he was assassinated several months later. (Courtesy of the University of Southern California, on behalf of the USC Special Collections.)

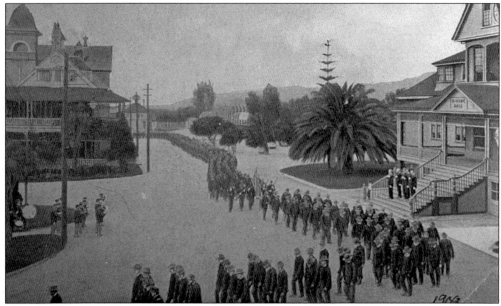

Postcard Souvenirs. Pictures of the Soldiers' Home were often made into postcards and sent by visitors to family back home. Here the patients are passing in review in front of the officers of the home standing on the dining hall steps. As the years went by, Civil War veterans were joined by soldiers who had served in the Spanish-American War and subsequent conflicts. Uniforms were provided from military surplus. (Courtesy of the Brentwood Historical Society.)

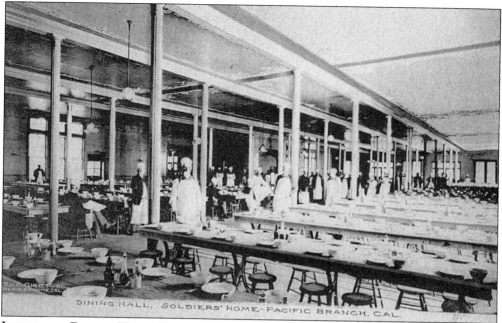

INSIDE THE DINING HALL. Veterans dined boardinghouse style on long tables and sat on stools in the community dining hall. No doubt they spent their meals reliving the exploits and adventures from their respective wars. The Civil War veterans called the Spanish-American soldiers "bamboos." No Confederate soldiers were allowed residence. (Courtesy of the Brentwood Historical Society.)

EXOTIC PLANTS CAME FROM ALL OVER. In this 1905 photograph, the barracks building is framed by lush vegetation cultivated by the veterans. Sailors coming into the port of Santa Monica often brought exotic plants collected during their travels to the veterans for their gardens. The Victorian architecture designed by well-known architect Stanford White featured porches and turrets. (Courtesy of the University of Southern California, on behalf of the USC Special Collections.)

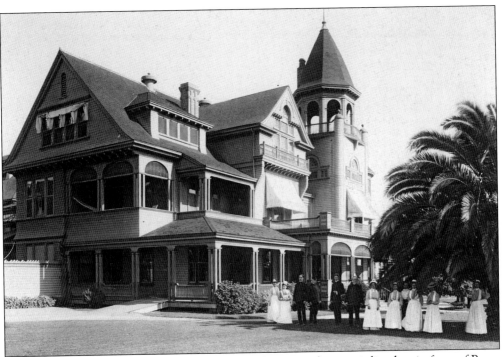

MEDICAL STAFF, 1905. Here the medical staff of doctors and nurses is lined up in front of Barry Hospital, built in 1900. When the hospital first opened, there were no nurses, so the veterans took care of each other. Women were added to the staff *c.* 1900. (Courtesy of the University of Southern California, on behalf of the USC Special Collections.)

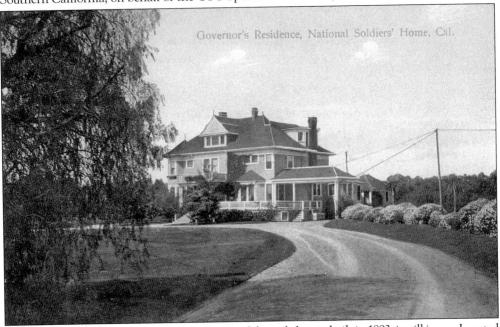

Governor's Residence, National Soldiers' Home, Cal.

THE GOVERNOR'S RESIDENCE. This spacious Eastlake-style home, built in 1893, is still in use. Located at the southern end of the property, it is the second-oldest building on the site. The staff consisted of a governor, a surgeon, and a treasurer. (Courtesy of the Brentwood Historical Society.)

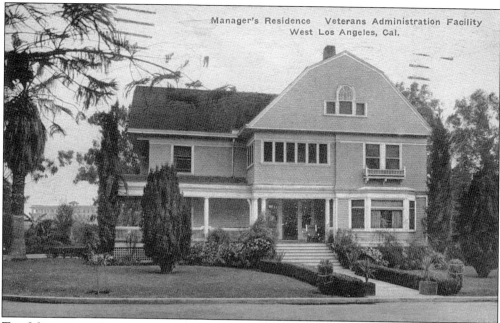

Manager's Residence Veterans Administration Facility
West Los Angeles, Cal.

THE MANAGER'S RESIDENCE. This postcard showed the manager's residence and was made at some point after the Soldiers' Home had come under the control of the Veterans Administration, which formed in 1930. The buildings constructed in the 1920s are visible in the background. (Courtesy of the Brentwood Historical Society.)

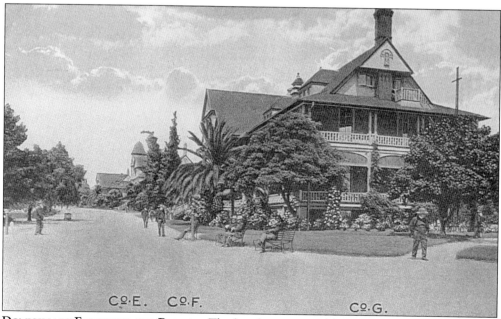

Cᵒ·E. Cᵒ·F. Cᵒ·G.

DOMICILIARY FACILITIES AND BREEZES. The first dormitories of the Soldiers' Home were spacious, with wide porches to capture ocean breezes. In this postcard, veterans sit on benches and stroll through the parklike grounds. The veterans grew vegetables and tended orchards and livestock, supplying their own needs and selling the surplus. The home was self-sufficient and sometimes made a profit on these enterprises. (Courtesy of the Brentwood Historical Society.)

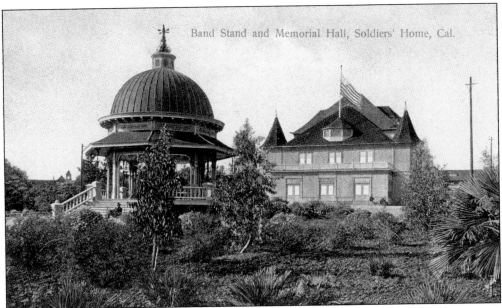

Band Stand and Memorial Hall, Soldiers' Home, Cal.

THE BANDSTAND. The copper-topped bandstand was the site of many concerts for the veterans. Other entertainments included taking the trolley to Santa Monica and Sawtelle for liquid refreshment. A popular saying of the day was, "Some sought heaven and some sought Sawtelle." There was a mile and half restriction on liquor sales around the home to help with this problem. (Courtesy of the Brentwood Historical Society.)

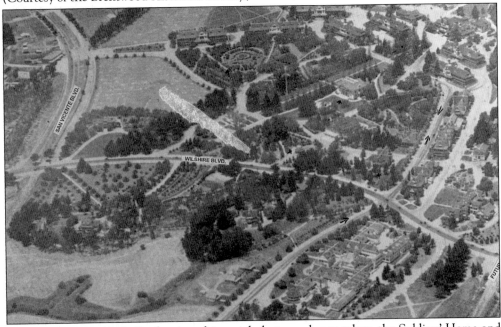

AERIAL VIEW, C. 1920. By the time this aerial photograph was taken, the Soldiers' Home and its landscaping were well established. Wilshire Boulevard had become a major thoroughfare, and there were now homes on San Vicente Boulevard. The bandstand is visible just north of Wilshire Boulevard, and the domiciliary facilities are on the right. (Courtesy of the Brentwood Historical Society.)

20

Three

THE PROMOTERS
CAPITALIZING ON A PARADISE

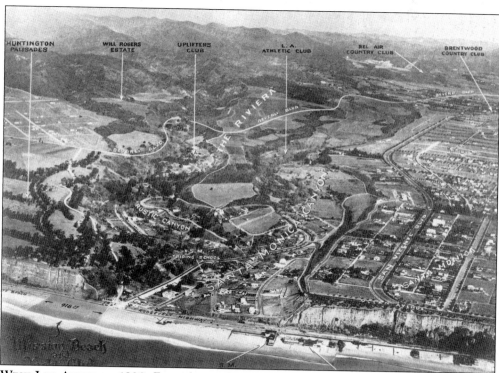

WEST LOS ANGELES, 1928. From this angle, it is possible to see much of the land that made up the San Vicente y Santa Monica Rancho, but it is much changed from the sea of grass that the Sepulvedas sold to Robert S. Baker in 1872. The men who bought it, subdivided it, and sold it must have been pleased to see the area developing into their vision of a community. The automobile and trolley had done away with the dusty, daylong horseback ride from Los Angeles. More and more people were buying lots and opening businesses. Brentwood, at the top right edge of the photograph is spreading outward from San Vicente Boulevard. Beverly Boulevard (soon to become Sunset Boulevard) snakes across the hills. Polo was as big a sport as golf. There were four polo fields—three at the Uplifters Club and one at Will Rogers and two golf courses—Bel Air and Brentwood Country Clubs. (Courtesy of the Santa Monica Land and Water Company Archives.)

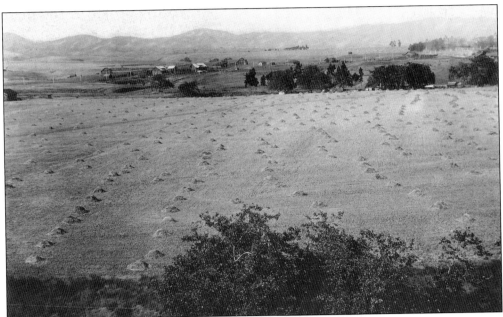

SAN VICENTE RANCHO FROM FRANKLIN HILL. Looking northwest, there are houses in the distance, but when this picture was taken barley, oats, hay, and lima beans were the big moneymakers for the promoters. In fact, the future Brentwood area had 12,000 acres of lima beans under cultivation. The beans were so good they won a silver medal at the St. Louis World's Fair in 1904. (Courtesy of the Santa Monica Land and Water Company Archives.)

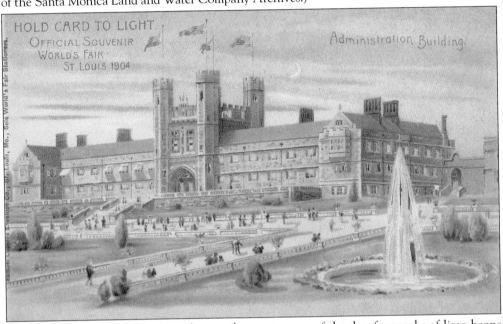

THE WORLD'S FAIR, 1904. According to the newspapers of the day, four sacks of lima beans grown on the rancho were sent to the World's Fair in St. Louis to compete against produce from all over the country. Silver medal in hand, the promoters crowed that they would soon out produce Ventura County. When this postcard is held up to the light it looks as though electric lights are on in the buildings. (Courtesy of the Santa Monica Land and Water Company Archives.)

WILLIAM EDWARD SAWTELLE. The man in the frock coat is W. E. Sawtelle, an early promoter of both Santa Monica and the land around the Soldiers' Home. He is seen here with his cousin Frances Lindsey Gillis and her daughter Adelaide Gillis. Like Gillis, Sawtelle was from Norridgewock, Maine. He was a banker and an investor in the early developments created at the south entrance to the Soldiers' Home. (Courtesy of the Santa Monica Land and Water Company Archives.)

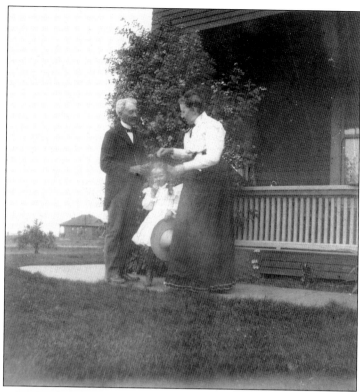

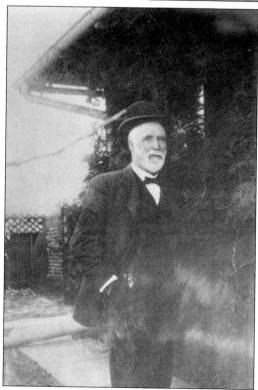

NATHAN PEARL BUNDY. Bundy was an early resident of Santa Monica, moving to the area from Iowa. He was active in the community as a real estate investor and promoter. All five of his sons were also prominent businessmen in the area. This photograph was probably taken at his Westgate home around 1913. (Courtesy of the Santa Monica Public Library Image Archives.)

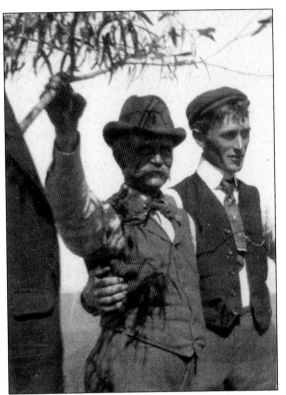

WILLIAM J. VAWTER. The Vawter family, early settlers in Santa Monica, opened the area's first general store in 1876. W. J. Vawter (left) was active in numerous business ventures, including the street railroad that became the Los Angeles Pacific Railway and the Merchants National Bank of Santa Monica. Dr. Charles Lindsey stands at right. (Courtesy of the Santa Monica Land and Water Company Archives.)

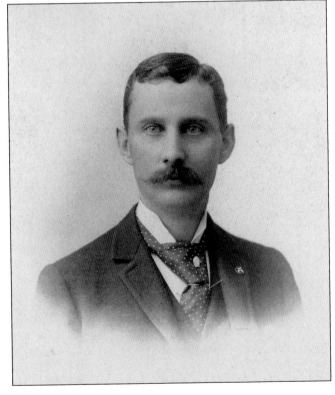

WILLIAM TEMPLETON GILLIS. W. T. Gillis immigrated to Santa Monica from Pictou, Nova Scotia, and set up shop as a druggist in the growing town. With his brother R. C. Gillis, he was active in the development of the land located outside the southern gate of the Soldiers' Home. He was an investor in the Bank of Santa Monica and many other enterprises important to the burgeoning area. (Courtesy of the Santa Monica Land and Water Company Archives.)

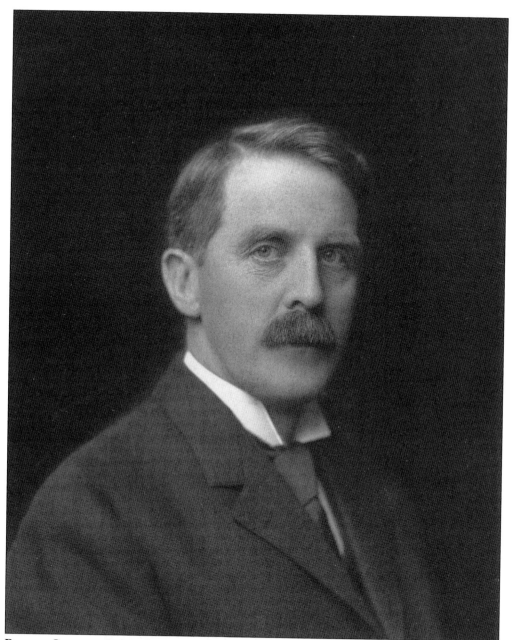

ROBERT CONRAN GILLIS. R. C. Gillis followed his brother W. T. Gillis to Santa Monica from Nova Scotia in the mid-1880s. Both brothers rapidly discovered that real estate and railroads were better investments than drugstores. By 1902, Gillis was buying up real estate in the West Los Angeles area. He was active with his brother in several companies that were subdividing land near the Soldiers' Home. In 1905, he completed the purchase of all of the Santa Monica Land and Water Company stock from Arcadia Bandini de Baker and Sen. John P. Jones, giving him ownership of the remaining open land of the Rancho San Vicente y Santa Monica. Over the next 40 years, he subdivided the land into numerous residential and commercial areas. Gillis met and married Frances Lindsey of Norridgewock, Maine, in Santa Monica. (Courtesy of the Santa Monica Land and Water Company Archives.)

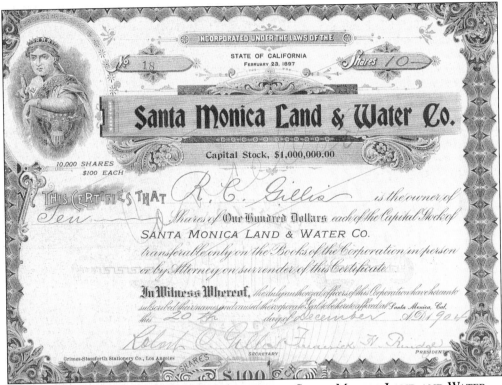

SANTA MONICA LAND AND WATER COMPANY STOCK. Incorporated in 1897 by Arcadia Bandini de Baker and Senator Jones to hold their real estate investments, the Santa Monica Land and Water Company owned the land of the Rancho San Vicente y Santa Monica. These 10 shares were issued to R. C. Gillis as a director in 1904. He purchased the balance of the stock in 1905. (Courtesy of the Santa Monica Land and Water Company Archives.)

MOSES HAZELTINE SHERMAN. Sherman moved to the Arizona Territory as a young man. Trained as a teacher, he was the first principal in Prescott and later was appointed adjutant general for the territory. Ever after, he used the title of General Sherman. Moving to Los Angeles in the 1880s, he started the Los Angeles Pacific Railway. His company built the trolley lines that served the Soldiers' Home and Westgate area. (Courtesy of the Sherman Library.)

ELI P. CLARK. Sherman's sister Lucy married Eli P. Clark, whom she met when visiting her brother in Arizona. Thereafter, Sherman and Clark were close business associates who invested in enterprises together. Clark came with Sherman to Los Angeles and was involved in his street railway ventures and other land investments. (Courtesy of the Sherman Library.)

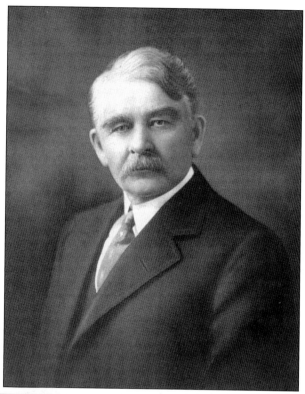

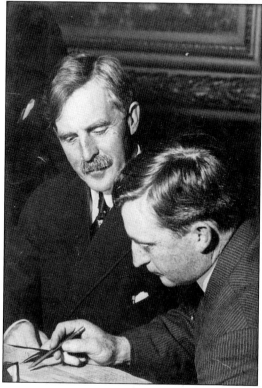

CHARLES LEROY BUNDY. One of five sons of Nathan Bundy, C. L. Bundy (right) worked for the Santa Monica Land and Water Company and was involved in many of the developments that became Brentwood. He owned a home in Westgate and raised his two sons there. R. C. Gillis (left) was the majority stockholder of the Santa Monica Land and Water Company until his death in 1948. (Courtesy of the Santa Monica Land and Water Company Archives.)

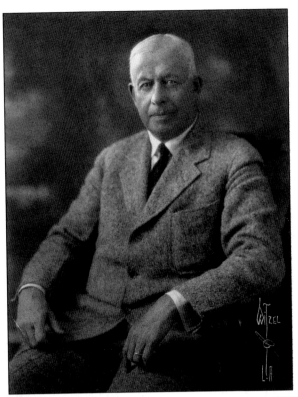

HARRY M. GORHAM. Senator Jones's nephew Harry Gorham worked for him in his mining operations and managed his Santa Monica investments. Gorham worked for the Santa Monica Land and Water Company and was on the board until he retired to Ojai. (Courtesy of the Santa Monica Land and Water Company Archives.)

LAURENCE DUNCAN LOOMIS. Raised in Kansas, Loomis came to California with his parents, brother, and sister. He moved to Santa Monica in about 1900. Loomis supervised much of the grading of the first tracts west of the Soldiers' Home. He lived in Westgate for many years, raising two boys there. His sister Hallie married C. L. Bundy. (Courtesy of the Santa Monica Land and Water Company Archives.)

Four

THE STREETS

BUILDING A SUBURB

STREET NAMES. The developers of Brentwood had the privilege of naming the streets, and they often named them for each other. From left to right are C. L. Bundy (Bundy Drive), R. C. Gillis, Harry Gorham (Gorham Avenue), Louis Evans, and Frank Lee. These men were all executives of the Santa Monica Land and Water Company, the owner of the San Vicente Rancho by 1897. The streets make odd angles with San Vicente Boulevard because they were originally designed as residential streets lined up with the western boundary of the Soldiers' Home. (Courtesy of the Santa Monica Land and Water Company Archives.)

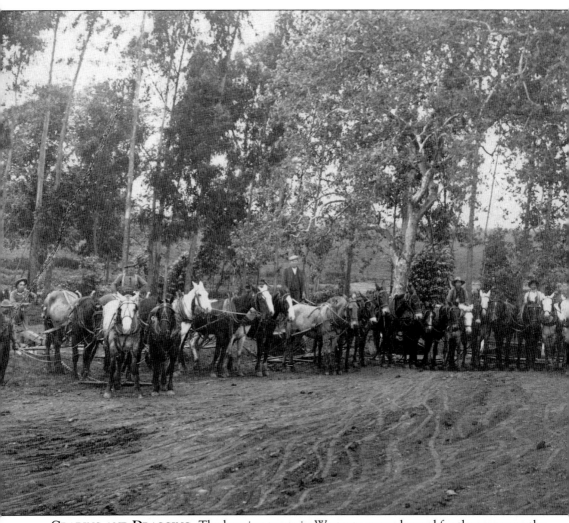

GRADING AND DRAGGING. The housing tracts in Westgate were planned for the area near the west gate of Soldiers' Home. Grading began in 1904 and was done with mules, horses, Fresno Scraper (a piece of equipment pulled level to the ground by horses), and man power. These men stopped work and lined up to pose for this picture behind their supervisor—the man in the dark

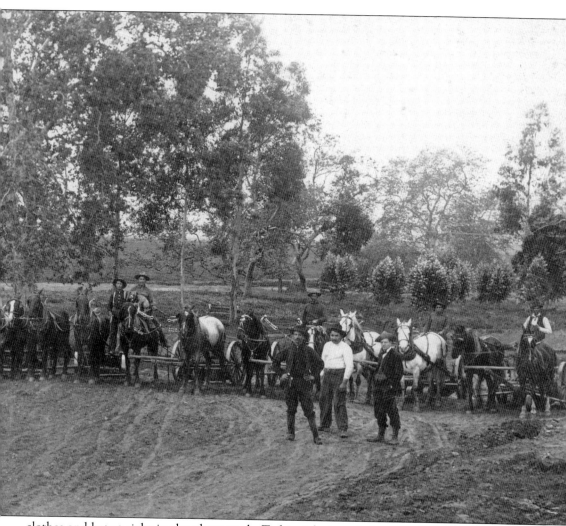

clothes and hat at right in the photograph. To his right in a dark suit is C. L. Bundy, one of the developers of the tract. San Vicente Boulevard is visible in the background along with the hills that would soon be covered with houses. (Courtesy of the Santa Monica Land and Water Company Archives.)

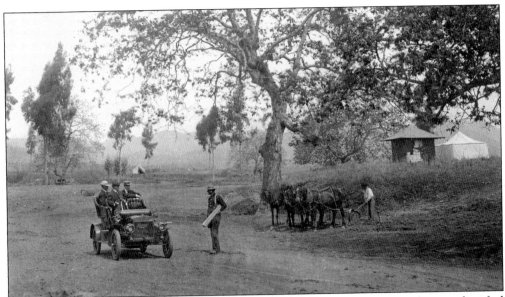

SUPERVISING THE JOB, 1905. L. D. Loomis (left) and C. L. Bundy (right), along with an unidentified chauffeur in front, are holding a meeting with the supervisor of the tract taking shape west of the Soldiers' Home. Note that the steering wheel is on the right side. Following the horse-and-buggy tradition, right-hand drive was standard in this country for automobiles until about 1908. (Courtesy of the Santa Monica Land and Water Company Archives.)

HORSE MEETS HORSELESS CARRIAGE. The Santa Monica Mountains and the first houses built along San Vicente Boulevard are seen in the background of this photograph taken near Montana Avenue and South Bundy Drive. Since the roads were all dirt in 1905, driving this Cartercar around the site was a real adventure. Here L. D. Loomis drives as the chauffeur watches. C. L. Bundy is in the rear of the car. (Courtesy of the Santa Monica Land and Water Company Archives.)

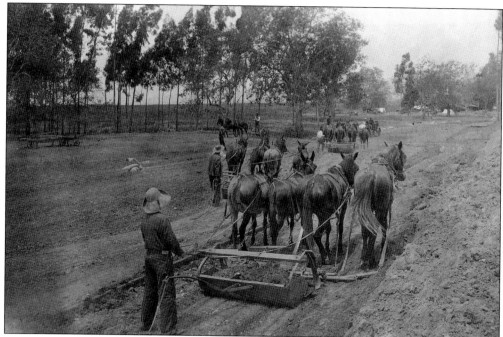

ROAD GRADER, 1905 STYLE. The Fresno Scraper was a true breakthrough in earth-moving equipment, changing it from a hand-loaded and hand-emptied process to a single sequence of loading, carrying, and dumping. Invented in Fresno, the "Fresno" was in common use for road building by the early 1900s. This crew is working on San Vicente Boulevard. (Courtesy of the Santa Monica Land and Water Company Archives.)

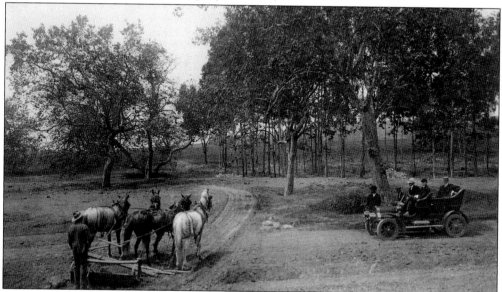

SAN VICENTE BOULEVARD TAKES SHAPE. Gen. M. H. Sherman took a personal interest in the development of San Vicente Boulevard. In a letter dated February 25, 1905, he writes, "I have become very interested in the whole matter and wish you might make oiled streets, and make them as good as asphalt, and people would come from everywhere to ride over them in their automobiles." (Courtesy of the Santa Monica Land and Water Company Archives.)

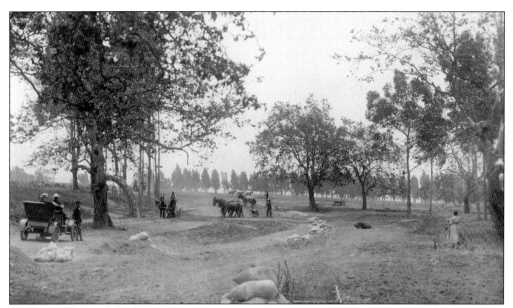

SIDEWALK SUPERINTENDENTS. C. L. Bundy, L. D. Loomis, and their chauffeur watch the progress of the street grading for their new subdivisions. An unidentified woman at the right delivers lunch. While mules and horses were doing the grading, the roads were being built for automobiles. (Courtesy of the Santa Monica Land and Water Company Archives.)

SOUTH BUNDY AVENUE AND MONTANA AVENUE, 1905. The unidentified man seems to have charge of the entire project since he is often in the photographs with C. L. Bundy and L. D. Loomis. San Vicente Boulevard is in the background. The development of the tract has progressed; trees have been removed and workers are installing curbs. The building on the left with the words on it is the sales office. (Courtesy of the Santa Monica Land and Water Company Archives.)

DOROTHY GILLIS, 1905. The younger daughter of R. C. Gillis, Dorothy Gillis gave her name to one of the streets below South Bundy Avenue. Originally the street was to be named Sherman Avenue, but it was changed to Dorothy Street perhaps because the post office found a duplicate somewhere in Los Angeles. Adelaide Drive in Santa Monica is named for her older sister. (Courtesy of the Santa Monica Land and Water Company Archives.)

SAN VICENTE BOULEVARD, 1907. Gen. M. H. Sherman's letter to R. C. Gillis described San Vicente Boulevard as "the finest boulevard." The decorative scroll work on the poles for the trolley lines, the double tracking, the trees, and sidewalks all show the care that was going into this street. The boulevard is wide and obviously designed to carry traffic as the main thoroughfare of the tract. (Courtesy of the Santa Monica Land and Water Company Archives.)

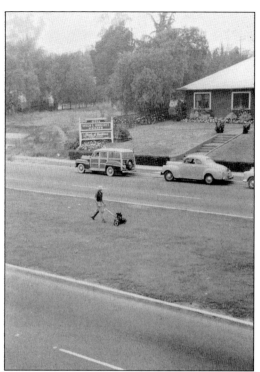

SAN VICENTE BOULEVARD, LATE 1940S. Around 1942, the trolley tracks were removed from San Vicente Boulevard, ending the trolley era for Brentwood, and the rail was used as scrap in the war effort. The median strip was planted with grass and used for horseback riding. The sign advertises Byron E. Vandegrift, builder. The "woody" was a popular car of the day. (Courtesy of the Brentwood Historical Society.)

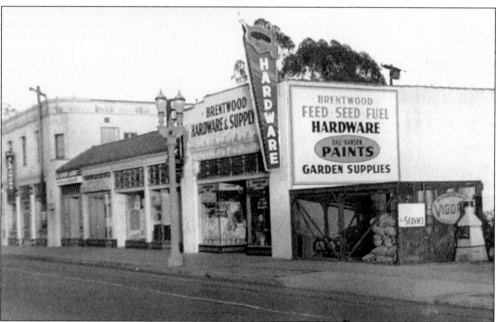

FEED, SEED, AND FUEL. By the late 1940s, the homes on San Vicente Boulevard had given way to a shopping district built to serve the growing population. This building was constructed in 1928 and housed the library from 1935 to about 1947. Brentwood Hardware thrived after World War II as more homes were built in the neighborhoods. The building is still there although with different tenants. The hardware store, which became the Duck Blind, is now a Blockbuster. (Courtesy of the Brentwood Historical Society.)

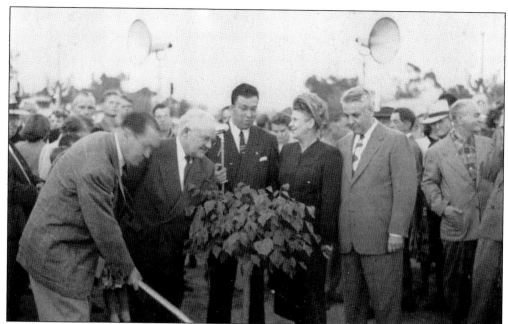

BEAUTIFYING SAN VICENTE, 1949. Once the tracks were removed, the median strip on San Vicente Boulevard was functional but not beautiful. A grant from the Los Angeles Beautiful program allowed visionary residents to plant 5 miles of coral trees starting at the Soldiers' Home. The trees' red flowers enliven the street every spring, and their twisted shape is the icon for Brentwood. This group is ceremoniously planting one of the coral trees. (Courtesy of the Brentwood Historical Society.)

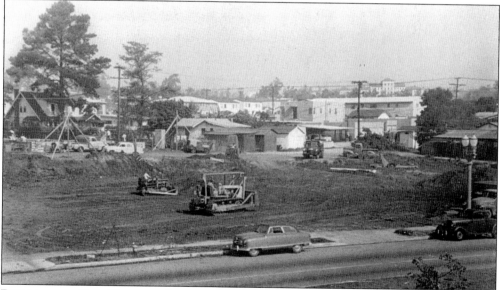

BUILDING ON SAN VICENTE. Construction begins north of San Vicente Boulevard, west of Gorham Avenue. The site, first used by Westward Ho market, is now the site of the Whole Foods store. The coral tree in the foreground is still small so this was taken in the late 1950s or early 1960s. Apartments are beginning to replace the single-family homes to the north. (Courtesy of the Brentwood Historical Society.)

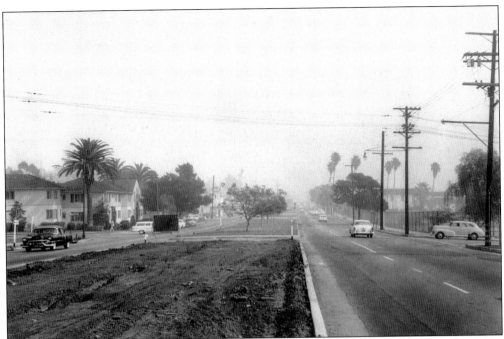

San Vicente Boulevard at Gretna Green. Looking east down San Vicente Boulevard, the median is being prepared to plant more grass and coral trees. On the left the fence of Brentwood Elementary School is visible. Traffic is light. (Courtesy of the Brentwood Historical Society.)

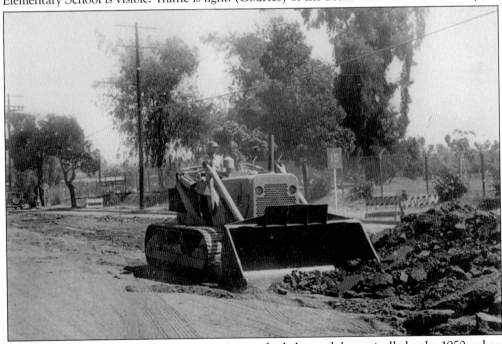

Paving San Vicente. Earth-moving equipment had changed dramatically by the 1950s when this paving job was going on. It required only one man to run the bulldozer instead of four mules or horses. The school zone speed limit was 15 miles per hour. (Courtesy of the Brentwood Historical Society.)

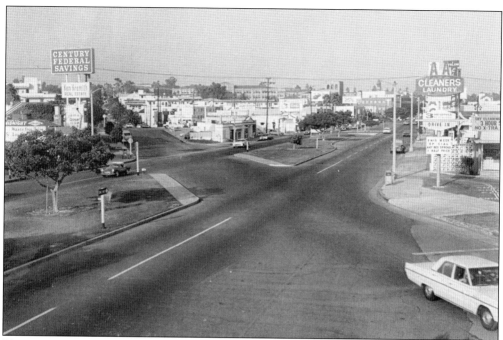

THE 1960S BRING CHANGE. The intersection of San Vicente Boulevard and Gorham Avenue has become a busy commercial district with flashing signs and taller buildings. Left turn lanes and stop signs have been added to handle the increasing traffic. (Courtesy of the Brentwood Historical Society.)

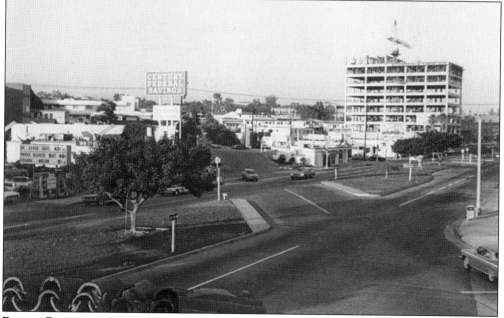

BIGGER BUILDINGS RISE. This photograph is also of the intersection of San Vicente Boulevard and Gorham Avenue but now there is a new office building under construction on the north side of the street. Today the building houses offices, a bank, and the Cheesecake Factory. (Courtesy of the Brentwood Historical Society.)

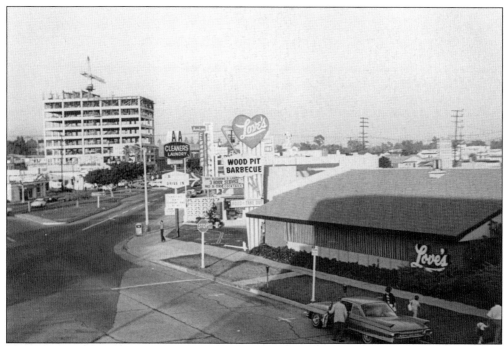

San Vicente Boulevard and Gorham Avenue. Love's Barbeque, an institution in Brentwood for many years, was located at Gorham Avenue and San Vicente Boulevard. Some of the small houses built in the original tracts are visible in the background. (Courtesy of the Brentwood Historical Society.)

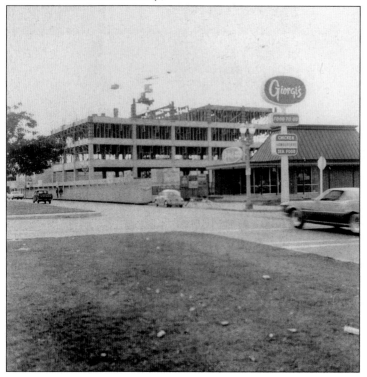

Darlington Avenue at San Vicente Boulevard. Giorgi's became Regular Johns, the pizza parlor of choice during the 1970s and 1980s for Brentwood residents. Parents and kids loved Regular Johns because the pizza was good, there were video games, and movies played all the time. It lives forever as the pizza place in *Ferris Bueller's Day Off.* (Courtesy of the Brentwood Historical Society.)

NEVADA AVENUE. According to the newspapers of the day, it was known as "the horse and buggy picnic route to the Pacific." The dirt road ran through Senator Jones's land and was named for his home state. By 1929, the road was paved all the way through to downtown Los Angeles and renamed Wilshire Boulevard. (Courtesy of the Santa Monica Land and Water Company Archives.)

SHADE AND GRASS. This section of Nevada Avenue, pictured here in 1905, probably looks a great deal like the track that the Native Americans and Californios used to bring their tar from La Brea to Santa Monica for shipping. C. L. Bundy and L. D. Loomis found a shady spot to hold their meeting and pose for the camera. (Courtesy of the Santa Monica Land and Water Company Archives.)

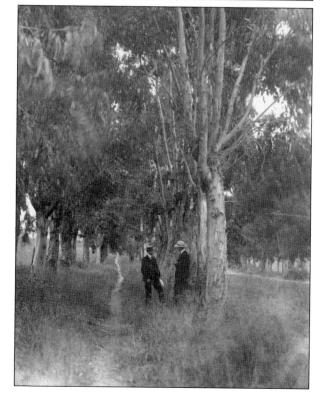

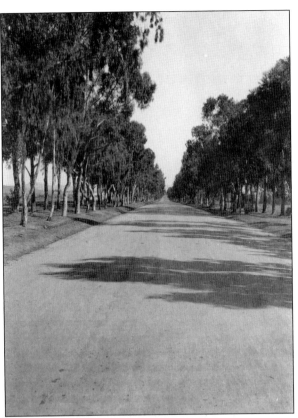

WILSHIRE BOULEVARD. By 1929, Wilshire Boulevard was paved all the way through to downtown Los Angeles. The entire street was renamed for Gaylord Wilshire, who developed Westlake Park (now MacArthur Park) and named the portion of the street that ran through his development for himself. The name stuck. (Courtesy of the Santa Monica Land and Water Company Archives.)

BARRINGTON AVENUE LOOKING NORTH, 1930. Billboards and utility poles obscure the view of the mountains in this photograph taken from south of Wilshire Boulevard. Barrington Avenue is not paved, and there is a bridge over a culvert. One of the billboards advertises Chotiner for councilman. (Courtesy of the University of Southern California, on behalf of the USC Special Collections.)

Five

THE TROLLEYS

CONNECTING SUBURB TO TOWN

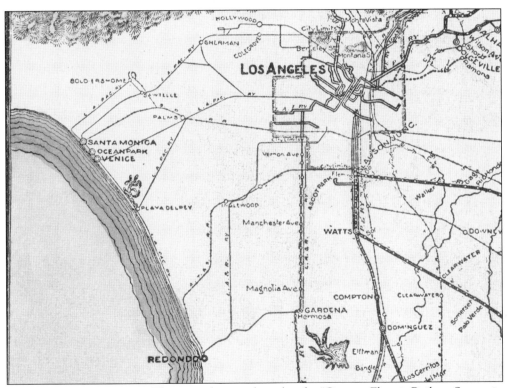

PACIFIC ELECTRIC ROUTES. The interurban was hyped as the "Greatest Electric Railway System in the World" at a dinner given on October 3, 1906. This detail shows the routes laid out for the area around the Soldiers' Home. Gen. M. H. Sherman and E. P. Clark started and built the interurban routes that were critical to the development of the San Vicente y Santa Monica Rancho. San Vicente Boulevard functioned as a major transportation route connecting Los Angeles to the Soldiers' Home area, bringing people and commerce to the region. A sign of Sherman's interest in this line and the residential area was the decorative iron scrollwork on the San Vicente Boulevard poles. (Courtesy of the Santa Monica Land and Water Company Archives.)

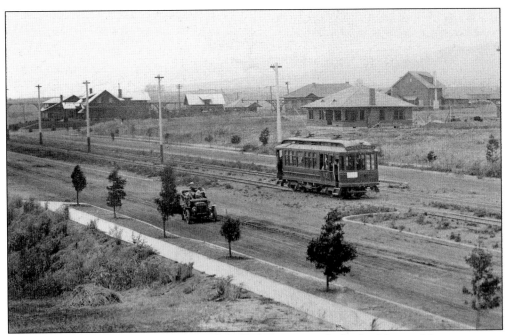

RACING THE TROLLEY. In this photograph, L. D. Loomis is in the back of the car, his younger son, Leroy (about age eight), is behind the wheel, and his older son, Arthur, is waving at the trolley. The conductor is standing in the door of the trolley car. Chasing the trolley on horseback was a popular pastime for the kids in the area. Apparently, the Cartercar was the only automobile traffic. (Courtesy of the Santa Monica Land and Water Company Archives.)

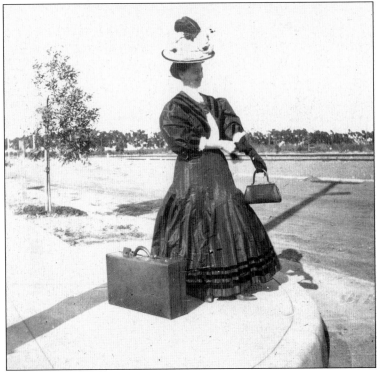

TROLLEY CATCHING. Martha Freeman waits for the trolley along San Vicente Boulevard. In 1905, women wore elaborate hats, gloves, and long skirts even when hopping on the green Los Angeles Pacific cars. The tracks are visible in the background. (Courtesy of the Santa Monica Land and Water Company Archives.)

THE BALLOON ROUTE. For a dollar, tourists could board the trolley in downtown Los Angeles and travel all day, stopping to see the sights along the way. The route included Hollywood, the Soldiers' Home, Santa Monica, Playa del Rey, Redondo Beach, Venice, and back downtown through Palms—101 miles. Each ticket included admission to the sights in each area, and the route resembled a balloon shape. (Courtesy of the Santa Monica Land and Water Company Archives.)

POSING AT THE SOLDIERS' HOME. A photographer posed Balloon Route passengers on the steps of the dining hall at the Soldiers' Home. The photographer would then take another trolley back to his studio and develop the photographs. He would rejoin the trolley at an afternoon stop and offer the photographs to the tourists as souvenirs. This photograph, taken in 1906, shows 23 people dressed for their excursion. (Courtesy of the University of Southern California, on behalf of the USC Special Collections.)

 Los Angeles Pacific Co.
ELECTRIC RAILWAY

The Shortest and Quickest Line
between Los Angeles and the Ocean

TO SANTA MONICA, OCEAN PARK, VENICE, REDONDO BEACH, SOLDIERS' HOME, SAWTELLE, SHERMAN, HOLLYWOOD AND COLEGROVE.

CANAL SCENE AT VENICE. "As seen on Balloon Route Excursion"

BALLOON ROUTE EXCURSION
The Greatest Moderate Priced Pleasure and Sight Seeing
Trip on the Pacific Coast

ONE WHOLE DAY FOR ONE DOLLAR
101 MILES FOR 100 CENTS

Showing some of California's finest scenery including 30 miles right along the Ocean, through Hollywood, Santa Monica, Ocean Park. Playa del Rey for dinner. Reserved Seats. An Experienced Guide with each Car.

The Only Electric Line Excursion Out of Los Angeles Going
One Way and Returning Another

FREE ATTRACTIONS—An Ocean voyage on wheels—The Excursion Cars running a mile into the Ocean on Long Wharf at Port Los Angeles, the longest pleasure and fishing wharf in the world. At Santa Monica, FREE ADMISSION to the CAMERA OBSCURA, an exclusive attraction for Balloon Route Excursionists only. At Venice FREE ADMISSION to the $20,000 Aquarium and a FREE RIDE on the L. A. THOMPSON SCENIC RAILWAY, the longest in the world. (Sundays excepted during July, August and September.)

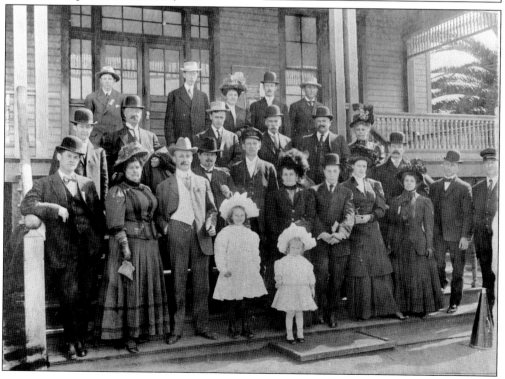

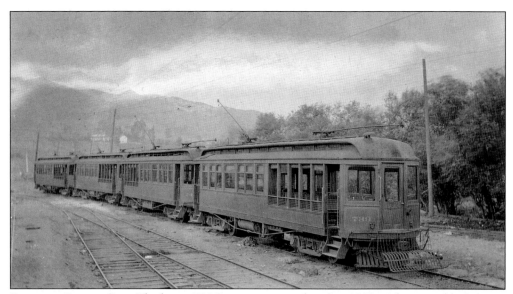

BALLOON ROUTE CAR. The larger 700 Series cars introduced in 1907 made it possible for more passengers to take the Balloon Route tour. At its height, there were four cars per day dedicated to the route, and the trip was considered the most famous trolley trip in the West. Tourists often returned to the Soldiers' Home area to purchase lots and build houses, making the route one of the best advertising ploys available. (Courtesy of the Santa Monica Land and Water Company Archives.)

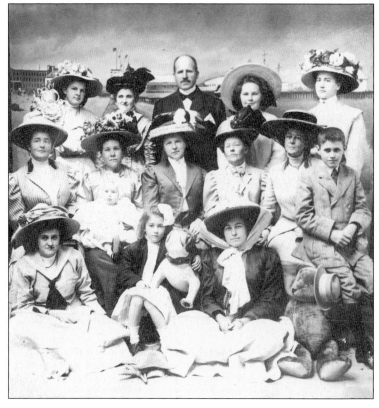

GEN. M. H. SHERMAN'S EXCURSIONS. General Sherman liked to have friends join him on the "Mermaid," his private car, for his own Balloon Route tours. In this photograph, Sherman is surrounded by the wives and children of his fellow promoters. In the second row, Frances Gillis and Gracie Loomis are third and fourth from the left, respectively. Sherman and Dorothy Gillis are second and third from the left in the third row. (Courtesy of the Santa Monica Land and Water Company Archives.)

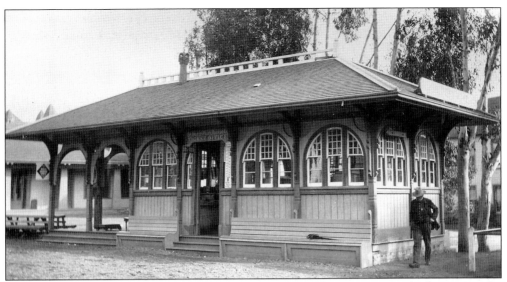

SOLDIERS' HOME STATION. The trolley station at the Soldiers' Home was built to serve the veterans, family, staff, and visitors traveling to the home. It still sits on its original site (now a parking lot) and is the oldest surviving building on the property. After its trolley days, the station was used as a newsstand for the home. (Courtesy of the Santa Monica Land and Water Company Archives.)

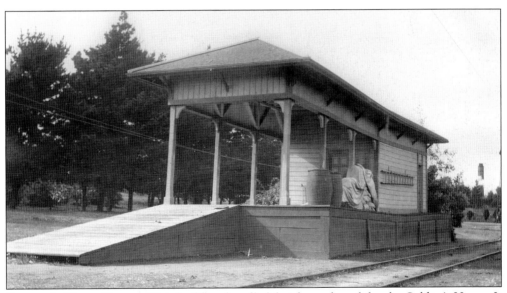

SOLDIER'S HOME DEPOT. This building handled freight and mail for the Soldier's Home. It was possible to run freight trains on the trolley tracks and there was regular service. The Gillis family moved horses this way, off-loading them at San Vicente Boulevard and walking them down the hill to their Sullivan Canyon stables. (Courtesy of the Santa Monica Land and Water Company Archives.)

THE PACIFIC ELECTRIC RAILWAY TAKES OVER.
In 1911, the Los Angeles Pacific Railway merged with the Pacific Electric Railway, uniting the two lines and creating a true interurban system for Los Angeles. The green cars gave way to the big Red Cars, but the trolleys continued to roll down San Vicente Boulevard until the early 1940s when the automobile and bus took precedence. (Courtesy of the Santa Monica Land and Water Company Archives.)

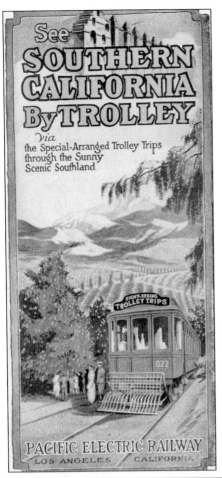

PASSES AND PRIVILEGES. The promoters and their families received passes that allowed them to ride the trolleys for free. This one was issued by the Pacific Electric Railway Company to Dorothy Gillis at age 16. She would often ride the trolley from Los Angeles to the family's summer home on Adelaide Drive near San Vicente Boulevard. (Courtesy of the Santa Monica Land and Water Company Archives.)

Six

THE NEIGHBORHOODS
CREATING COMMUNITIES

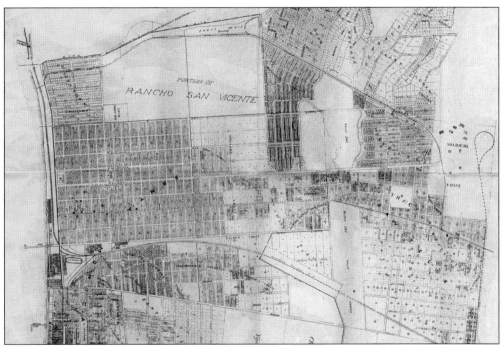

COMMUNITY DEVELOPMENT. This early map shows how the promoters who purchased the open land of the Rancho San Vicente developed the first residential tracts. The first neighborhood located outside the south gate of the Soldiers' Home was Sawtelle (lower right), named for banker and promoter W. E. Sawtelle. In 1905, development was begun on Westgate located outside the west gate of the home. Westgate Acres and Westgate Heights followed. Lots were smaller south of San Vicente Boulevard and larger north of the boulevard. In 1906, a group of developers purchased land north of San Vicente Boulevard and began to create Brentwood Park. Its traffic circles are clear at the top right of this map. At first, the entire area was called Westgate, but gradually the Brentwood name took hold, and by 1935, the area was generally known as Brentwood. Soon other neighborhoods were developed in the hills and canyons north of San Vicente Boulevard until the present community of some 41,000 plus residents was completely built out. (Courtesy of the Santa Monica Land and Water Company Archives.)

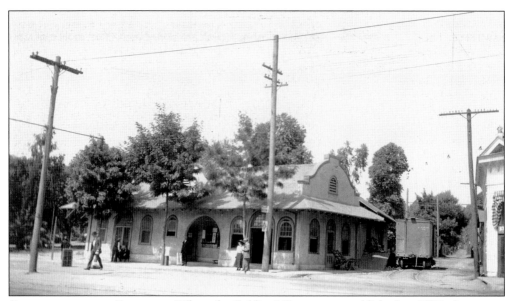

OPPORTUNITIES IN SAWTELLE. When the Soldiers' Home was established in 1888, there were no businesses or services closer than Santa Monica. It did not take long for people to see the opportunity the 1,000 patients and their pensions presented. Soon shops and businesses were locating outside the south gate of the home. The trolley line arrived in 1897. (Courtesy of the Santa Monica Land and Water Company Archives.)

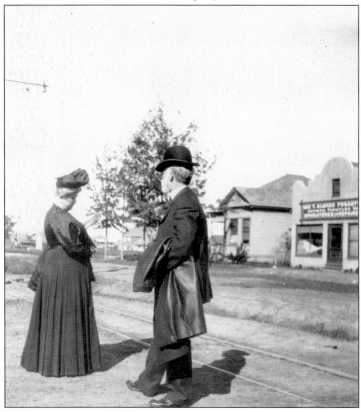

WAITING FOR THE TROLLEY. Nathan Bundy and his wife, Harriet, wait for the trolley by the tracks in Sawtelle. There is a furniture store in the background. Originally, the area was called Barrett Villa, but the post office rejected that idea. Banker and developer W. E. Sawtelle was given the honor instead. The town was part of Santa Monica but eventually became independent. It is now part of West Los Angeles. (Courtesy of the Santa Monica Land and Water Company Archives.)

INVESTING IN SAWTELLE. The Alta Santa Monica Company was formed to develop some of the land that became Sawtelle. This stock certificate shows that it was issued to Arcadia Bandini de Baker in 1905. Roy Jones, Senator Jones's son, and R. C. Gillis signed it. (Courtesy of the Santa Monica Land and Water Company Archives.)

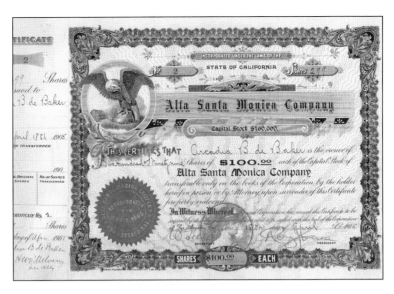

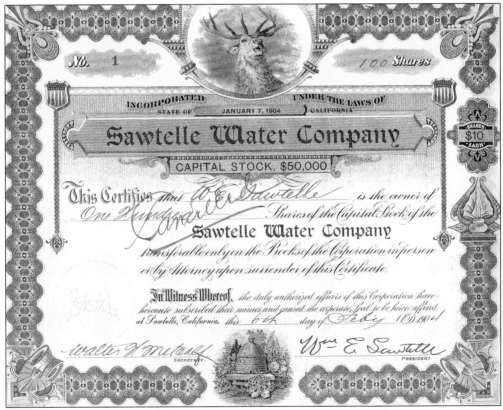

WATER INTERESTS. Having enough water was always an issue for the people living in the newly developed Sawtelle. W. E. Sawtelle was issued certificate No. 1, which was signed by him as the president of the company. Eventually Sawtelle would agree to consolidate with Los Angeles in order to ensure a reliable water source. It was a close vote though, the measure passed by only three votes. (Courtesy of the Santa Monica Land and Water Company Archives.)

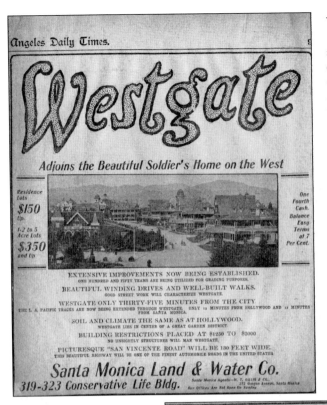

WESTGATE ADVERTISING. In 1905, the Santa Monica Land and Water Company began developing a tract of homes called Westgate. The name seems to have evolved from the fact that the lots were to be located right outside the west gate of the Soldiers' Home. This advertisement, written in the real estate jargon of the day, touts the proximity to the home as well as such amenities as winding drives and the new trolley line. (Courtesy of the Santa Monica Land and Water Company Archives.)

LOTS FOR $150. It was possible to buy residential lots in the new Westgate tract for $150; one-half-acre lots went for $350 and up. Setbacks from San Vicente Boulevard, the main street, were to be 25 feet. The trolley was touted as providing a 35-minute commute to Los Angeles. Restrictions specified that homebuilders had to spend a minimum of $2,500 on their homes. (Courtesy of the Santa Monica Land and Water Company Archives.)

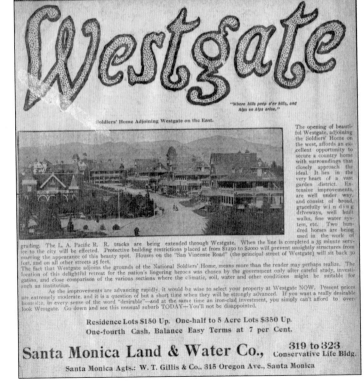

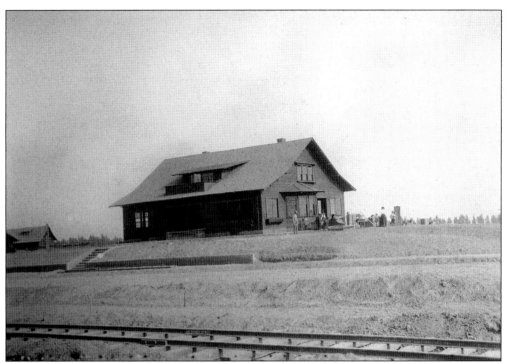

MOVING DAY. One of the earliest homes built on San Vicente Boulevard belonged to L. D. Loomis. This photograph seems to have been taken on moving day in late 1905 or early 1906; boxes and household goods are visible at right in the photograph. This house was located on the south side of the street near Barrington Avenue. (Courtesy of the Santa Monica Land and Water Company Archives.)

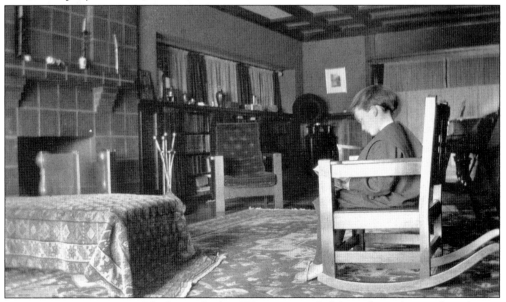

CALIFORNIA BUNGALOWS. The houses built at Westgate were California bungalows with craftsman overtones. Interiors were often fitted with bookshelves, and mission-style furniture was common. (Courtesy of the Santa Monica Land and Water Company Archives.)

ANOTHER BUNGALOW. This small home, pictured here in about 1925, was built on Westgate Avenue. Most of the original Westgate homes are gone, succeeded by apartments or bigger homes. However, a few survive, usually buried in landscaping. (Courtesy of the Brentwood Historical Society.)

WESTGATE HOME, 1938. There was a proposal to move this early Westgate home located on Barrington Avenue rather than destroy it for a construction project located south of Dorothy Avenue. A larger two-story home is visible in the background along with other houses. (Courtesy of the University of Southern California, on behalf of the USC Special Collections.)

RURAL LIFE. For many years, Westgate had more open land than houses. Many families kept horses, livestock, and poultry on their property. This mother and baby team look right at home. The children of the neighborhood were free to roam over the hills and vacant lots. (Courtesy of the Santa Monica Land and Water Company Archives.)

TRANSPORTATION IN WESTGATE, 1905. The Bundy and Loomis children grew up roaming the hills and canyons of Westgate barefooted and fancy-free. This picture was taken at the back of the Loomis house located on San Vicente Boulevard near Barrington Avenue. (Courtesy of the Santa Monica Land and Water Company Archives.)

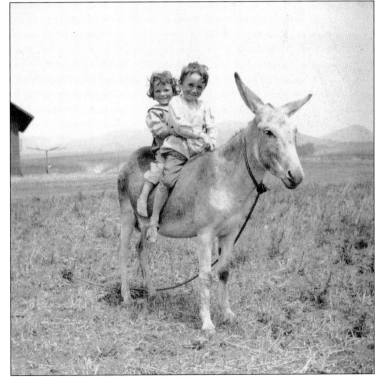

OAKS AND OPEN LAND. Nevada Avenue (Wilshire Boulevard) was more playground than thoroughfare when Westgate first opened. Here the oaks and grass have hardly been disturbed. The children are watching the photographer with great interest. (Courtesy of the Santa Monica Land and Water Company Archives.)

WESTGATE LANDSCAPING. Elaborate landscaping was added to Westgate homes as the years went by and the area became more built up. The homes along San Vicente Boulevard eventually were replaced by today's busy commercial zone, and most of the original Westgate neighborhoods are now apartments and condominiums. The burros and other livestock are long gone. (Courtesy of the Santa Monica Land and Water Company Archives.)

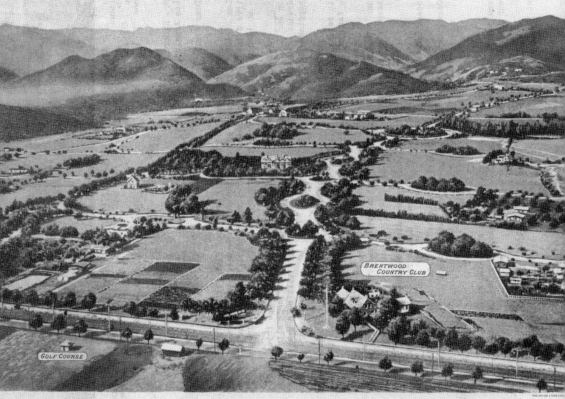

BIRDSEYE VIEW OF BEAUTIFUL BRENTWOOD PARK, LOS ANGELES, CAL.

PHOTOGRAPHED FROM AN AEROPLANE AT AN ALTITUDE OF 2500 FT.

DOES THIS ANTICIPATE YOUR DREAM OF A CALIFORNIA HOME?

BRENTWOOD PARK. In 1906, the Western Pacific Development Company acquired 350 acres of land from the Santa Monica Land and Water Company at $3,000 per acre. The promoters included a number of well-known individuals such as W. S. Vawter and William Lynton Brent, president of the Merchants Trust Company Bank. Continuing the tradition begun with Sawtelle, the new tract was named Brentwood Park after its banker. The tract was supposed to be built around 36 traffic circles, and the developers promised a half million dollars in improvements. They also established guidelines and restrictions to "insure a natural and pastoral setting." Wide graveled and oiled streets were laid out to follow the contours of the land. This drawing, on the back of the tract stationary, shows an idealized picture of the development as it existed in 1920. (Courtesy of the Santa Monica Land and Water Company Archives.)

57

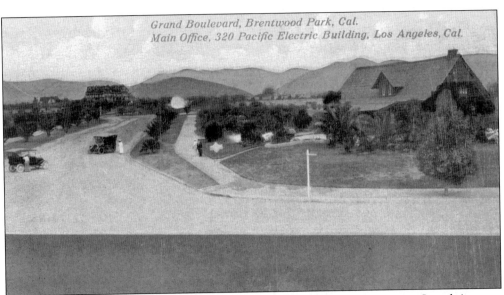

Grand Boulevard, Brentwood Park, Cal.
Main Office, 320 Pacific Electric Building, Los Angeles, Cal.

GRAND AVENUE. The centerpiece of the Brentwood Park development was Grand Avenue. After the annexation, it was renamed Bristol Avenue. This postcard was produced for tourists traveling the Balloon Route down San Vicente Boulevard. No doubt the conductors pointed out the upscale Brentwood Park subdivision to their passengers. (Courtesy of the Santa Monica Land and Water Company Archives.)

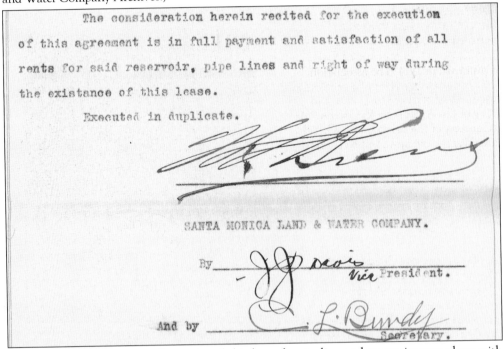

The consideration herein recited for the execution of this agreement is in full payment and satisfaction of all rents for said reservoir, pipe lines and right of way during the existance of this lease.

Executed in duplicate.

SANTA MONICA LAND & WATER COMPANY.

By _____ Vice President.

And by _____ Secretary.

W. L. BRENT'S SIGNATURE. Brent signed this lease for pipeline and reservoir space along with Joseph Jefferson Davis and C. L. Bundy. Brent came to California from Maryland in 1903 and plunged into real estate development. During his career, he was president of the Los Angeles Realty Board and involved in a number of real estate deals. (Courtesy of the Santa Monica Land and Water Company Archives.)

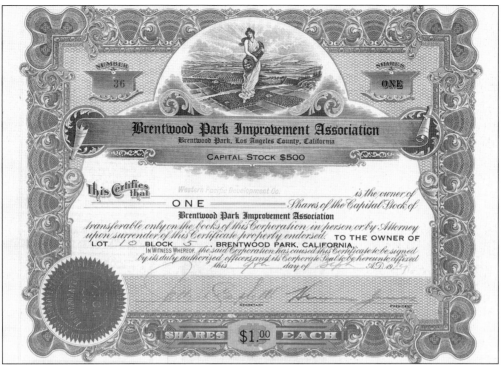

THE BRENTWOOD PARK IMPROVEMENT ASSOCIATION. This certificate was issued to the owner of Lot 10, Block 5 of Brentwood Park, California, in 1914. The association handled the trees, sidewalks, and other improvements to the tract until the City of Los Angeles took over the area. (Courtesy of the Santa Monica Land and Water Company Archives.)

ADVERTISING THE TRACT. The Western Pacific Development Company advertised their new tract widely in order to bring in as many people as possible. This advertisement for Brentwood Park ran in the *Pacific Monthly* magazine around 1920. The sales pitch talked about 80,000 trees and graceful winding walks. (Courtesy of the Santa Monica Land and Water Company Archives.)

Brentwood Park

Statistics show that a large percentage of the people who visit Southern California, especially Los Angeles, are purchasing property for future use, or for an investment. The rapid growth of the city and its surroundings are increasing very rapidly. Choice locations which command all the essential points are getting harder to purchase every day. This is especially so in Brentwood Park, the ideal home place.

Eighty thousand trees and shrubs, eight hundred varieties, are now being planted in Brentwood Park. Graceful, winding walks, drives and boulevards are all through the park. A mammoth garden, covered with a wreath of foreign trees and shrubs—there is nothing like it in Southern California. Brentwood Park is the only reproduction of the Golden Gate Park, at San Francisco. Sixty miles of an ocean sweep, one and a quarter miles from the ocean, still just far enough back to escape any harsh winds; entirely frostless; no fogs; the best of soil; the best of water and in abundance.

Great activity is now taking place in this location. You can't possibly make a mistake if you buy a lot in Brentwood Park. Do it now. Don't put it off. You may not want to use it just now, but you will be glad in the future. As an investment, nothing better; as a homesite, the very best. Large villa lots for sale at fifteen hundred dollars and up, according to the location and the size of the lots. Easy terms. The best transportation. The Los Angeles-Pacific main line passes Brentwood Park, on the beautiful San Vicente Boulevard.

Investigate and investigate at once. We refer you to all of Los Angeles. Write us today for plats, maps and prices, which will be sent cheerfully to all. Address

Western Pacific Development Company
OWNERS
203-204 Germain Building
LOS ANGELES, CALIFORNIA

Don't forget to mention The Pacific Monthly when dealing with advertisers. It will be appreciated.

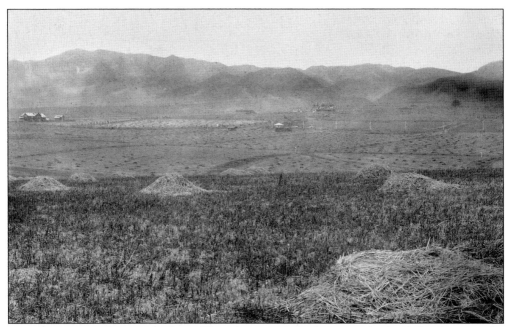

THE VIEW FROM FRANKLIN HILL. This photograph looks across the land that became the Brentwood Country Club, toward Brentwood Park. The building to the left of center is at the corner of Bristol Avenue and San Vicente Boulevard. There is another large residence visible in at left. (Courtesy of the Santa Monica Land and Water Company Archives.)

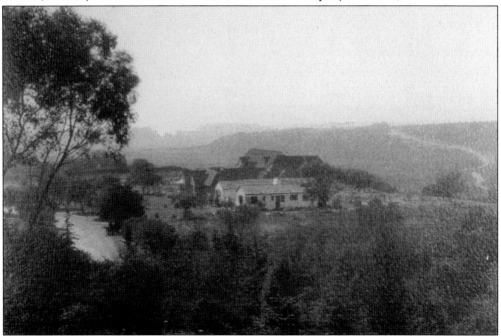

ROCKINGHAM AVENUE, 1925. This home is on Rockingham Avenue just south of Beverly Boulevard, which winds away in the distance. Rockingham Avenue overlooks Rustic and Sullivan Canyons. Beverly Boulevard's name was changed to Sunset Boulevard in 1929. (Courtesy of the Santa Monica Land and Water Company Archives.)

BRENTWOOD PARK ADDITION.
Block 24 of Brentwood Park was
subdivided around 1926. This
hand-drawn map shows the six lots
that face Twenty-sixth Street and
Bentel Street. These lots were being
sold by the Santa Monica Land
and Water Company. (Courtesy
of the Santa Monica Land and
Water Company Archives.)

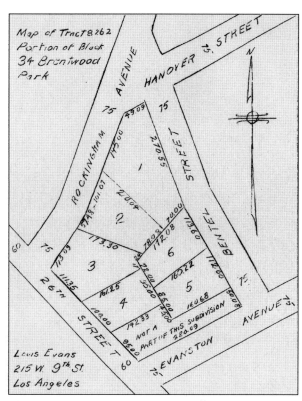

LOCATION, LOCATION. This 1926 price
list shows that two of the lots in Block
24 were already sold. The other lots
were priced from $17,000 for a corner
lot to $9,000 for one of the smaller lots
on Twenty-sixth Street. The restrictions
included a setback of 20 feet, as well
as a stipulation that all buyers must be
Caucasian. That provision was voided
in the 1960s by the Civil Rights Act.
(Courtesy of the Santa Monica Land
and Water Company Archives.)

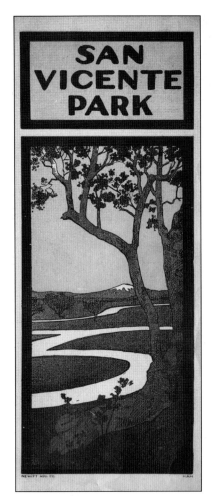

SAN VICENTE PARK. This art deco brochure was produced to sell the tract between Montana Avenue and Nevada Avenue (Wilshire Boulevard). The text waxes poetic about the sycamores that dot the landscape and the "vast Pacific—the greatest of all oceans." The brochure talks about $50,000 worth of improvements and compares the tract to Hollywood. (Courtesy of the Santa Monica Land and Water Company Archives.)

THE TRACT MAP. This early tract map from the sales brochure for San Vicente Park shows an ambitious layout of many lots and streets. Interestingly enough, this map shows South Bundy Drive as Arcadia Street, Dorothy Street as Sherman Avenue, and a Pennsylvania Avenue that was never built. This is a good illustration of how misleading developer tract maps can be. (Courtesy of the Santa Monica Land and Water Company Archives.)

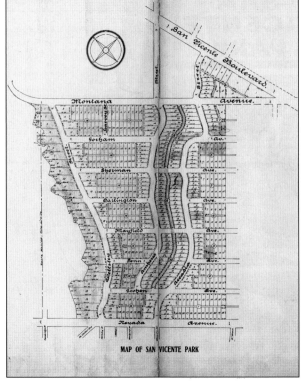

MAP OF SAN VICENTE PARK

REALITY CHECK. A working tract map for San Vicente Park produced in March 1907 shows that the developers had made significant changes to their plans. The tract is half its original size, and the street names have changed. Sherman Avenue is now Dorothy Street, and Amherst and Wellesley Streets have been taken off the map altogether. (Courtesy of the Santa Monica Land and Water Company Archives.)

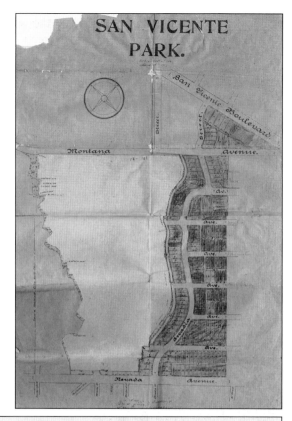

REAL ESTATE SPEAK. The inside of the San Vicente Park brochure promises that the new development will be the "most picturesque sub-division suburban to Los Angeles." The brochure goes on, "The usual rectangular lot has been avoided, some have rounded footage, some are triangular." The promoters are L. D. Loomis and the firm of Bundy and Schneider. (Courtesy of the Santa Monica Land and Water Company Archives.)

San Vicente Park

"Man Made the City — God Made the Country."

SAN Vicente Park is the place you have been looking for. It is a home sub-division for people who demand more than things ordinary.

San Vicente Park — on the San Vicente Boulevard, between the city and the sea—amid the spreading sycamores—is an ideal place to live.

San Vicente Boulevard—a broad highway "fit for a king" —runs directly through our property, on its way to the beaches. This grand road is one hundred and thirty feet wide and is one of the finest automobile drives in the West. It winds gracefully through as beautiful a country as California boasts of, and its smooth surface is a standing invitation to the autoist and equestrian.

The park itself is one of the most picturesque sub-divisions suburban to Los Angeles.

Westward stretches the vast Pacific—the greatest of all oceans—in the opposite direction the Sierras stand out in all their grandeur. Great sycamores, with gnarled and knotty limbs, lend ample shade from the summer's sun.

These trees are objects of wonder and awe. When Jefferson wrote the Declaration of Independence these same staunch sycamores were already here. They are grand, beautiful, and give character and strength to San Vicente Park.

On all sides of San Vicente are high-class sub-divisions, Brentwood Park, Beverly Hills, The Palisades, Westgate, upon which millions are being expended. The *wealth* is going to this wonderful section between the city and the sea. The best people in Los Angeles have homes in these suburban parks.

Prices in San Vicente Park, now lower than anything in the surrounding country, are sure to rise by leaps and bounds. It is an unusually high-class sub-division and the low prices are merely starters.

Fast cars on the Los Angeles Pacific Railway go straight to the Park. Service is reliable and frequent. Ten cent car fare by commutation.

In a short time, a very few months, the projected Harriman subway system will shorten the time to the city by half. This system is not merely talk, it soon will be a reality. Through the thickly settled portion of Los Angeles the trains will run underground.

Today a large army of men are changing San Vicente Park into a sub-division ideal, with all the conveniences of the city, but without its noise, its dust, its dirt and its heat.

The improvements will include cement walks, cement curbs, graded streets, made smooth and dustless with oil, a bounteous water supply, electric lights, telephone service. What location can boast of more up-to-date conveniences?

In size San Vicente Park does not equal its neighbors. This will tend to make it more exclusive and homelike. The $50,000 which is being expended for improvements will do as much as many times that sum would do in a larger park.

Large lots are the only kind that you will find in San Vicente. The usual rectangular-shaped lot has been avoided, some have rounding frontage, some are triangular. In size they run from 50 to 150 feet front by 150 to 350 feet in depth. Can you duplicate this for the absurdly low prices that we are asking?

A good graded school is on the property; a better one will soon take its place.

High-class building restrictions will be enforced—not so high that you could not afford to build, but sufficient to keep out undesirable structures.

The prices will surprise you—$500 and up — easy — very easy terms.

Mild, equable climate, metropolitan conveniences with country air and freedom from dust, accessibility to Los Angeles, good schools, large lots, picturesque surroundings —what more could you ask for?

Frost is absolutely unknown in this district. Every variety

tropical fruits — in fact almost anything will flourish successfully here.

Pure water in abundance and excellent drainage are features of San Vicente Park.

Our property lies in the cradle of California's greatest garden district. And that means the greatest in America. Even Hollywood can not excel our soil and climatic conditions. A great abundance of winter vegetables comes from this section.

At Hollywood property is quoted at many times our prices. But San Vicente Park is almost as near the heart of Los Angeles' business district by electric car.

Maps, prices and detailed information can be obtained at our offices. Prices are sure to advance shortly. Early purchasers in San Vicente Park have an exceptional opportunity to establish a home or to make money. We reserve the right to advance prices without notice.

While we do not wish to urge you unduly we will say that Opportunity can only be grasped by the forelock. Any man who wishes to establish a suburban home or to invest in suburban property can make no mistake in buying early in San Vicente Park. Its superiority to the flat country baffles comparison.

From Oregon to Mexico — California offers no such property as San Vicente Park.

Thirty minutes from growing Los Angeles — lots large — prices low — it is truly an opportunity worth grasping.

Bundy & Schneider

510-11 Bumiller Bldg. : 430 So. Broadway : Los Angeles

L. D. Loomis

Bundy Block :: :: :: Sawtelle

Office and Salesmen also on the Property. Take Santa Monica

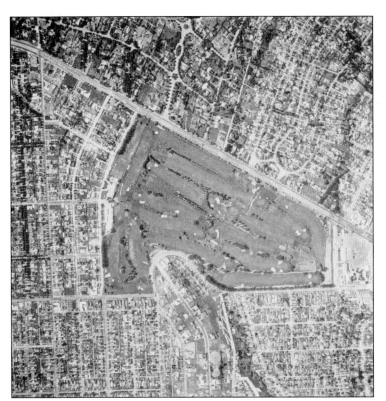

AERIAL MAP, 1950.
This aerial view shows
the development of
Brentwood during
its first 45 years.
Brentwood Park and
its traffic circles are
visible in the top left
of the photograph.
The Brentwood
Country Club is
obvious. This view
shows that the
original tract plan for
San Vicente Park was
eventually subdivided
and sold. (Courtesy
of the Santa Monica
Public Library
Image Archives.)

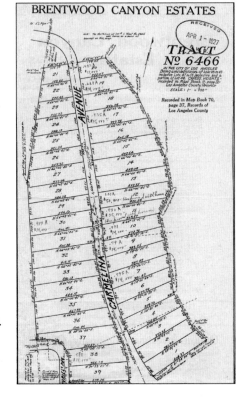

BRENTWOOD CANYON ESTATES. This tract
map was filed in April 1927 for the area east of
Brentwood Park. By this time, Brentwood had
become the prevailing name for the area, and
everyone was using the name for the development.
This subdivision was contoured to the land
and offered large lots with views over the mesa
and towards the hills. (Courtesy of the Santa
Monica Land and Water Company Archives.)

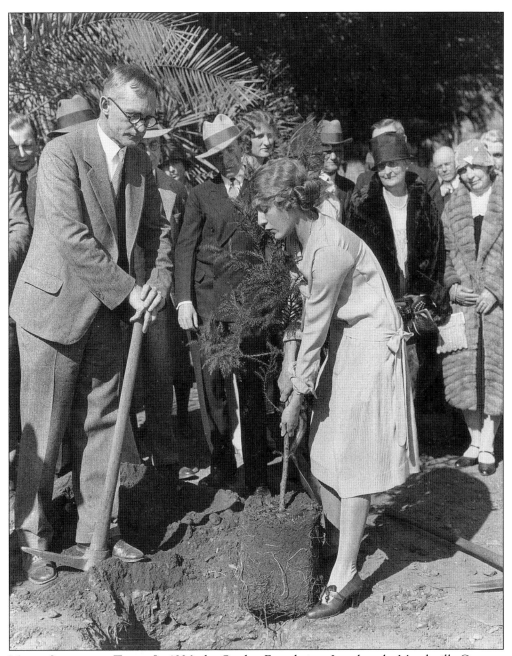

MOVIE STARS AND TREES. In 1926, the Garden Foundation, Inc., bought Mandeville Canyon, and designed and built an elaborate botanical garden with plantings from all over the world. Part of their sales strategy was to develop homes on the slopes overlooking the garden. Mary Pickford is shown here planting the first tree in the garden—a Japanese cryptomeria. Over 1,200 species were eventually planted; many still exist. Development of the area slowed and then stopped during the Depression. Construction resumed after World War II with 300 homes built in Upper Mandeville by 1958. Many of the homes in the canyon have stables, and horses are still popular. (Courtesy of the Security Pacific Collection/Los Angeles Public Library.)

R. A. CHAPIN
REAL ESTATE and INSURANCE

12,950 San Vicente Boulevard
Opp. Brentwood Park

J. J. COMER
Manager

TELEPHONE 21228
Santa Monica Ex.

Facts About Brentwood

This district comprises an area of about three square miles and lies partly in Los Angeles and partly in Santa Monica, at an elevation of 300 to 400 feet above sea level. Being thus situated on high ground, two miles from the ocean and adjoining the famous Palisades, yet less than forty-five minutes from Broadway, Los Angeles, Brentwood is superior to any other locality in Southern California as a place of residence.

The climate, both summer and winter, is as nearly perfect as California can boast, with much less fog than is known either to the east, along the foot-hills, or to the west nearer the ocean, and with positively no frost.

Added to which are well paved streets, with the customary improvements of water and gas mains, telephones, lights, et cetera, and restrictions that will insure the district remaining a high-class residence section for an indefinite period, with a single block, centrally located, allowed for shops.

The class of people throughout Brentwood, almost all of whom own their present homes, is the kind you will enjoy having as neighbors, and the Brentwood Country Club furnishes opportunity for exercise and for social life.

Building lots run in size from 50x150 feet up to 100x300 feet, and in price from $1500.00 to $10,000.00, while residences may be bought at prices ranging from $7,500.00 to $75,000.00, with a few estates at higher figures.

There is not a single objectionable feature connected with the Brentwood district, and we will be glad to assist you in choosing a home or a lot on which to build. Courteous attention and full information regarding properties at our office.

We Have Complete Listings

Brentwood Park
Brentwood Place
Brentwood Terrace
Brentwood Knoll

Canon Vista Park
Gillette's Regent Square
Palisades
Country Club Estates

and other properties in this vicinity

BRENTWOOD PLACE. Developers and promoters continued to subdivide land in Brentwood during the 1920s and 1930s. Brentwood Place is technically in Santa Monica, but the promoters wanted the clout of the image that was developing around Brentwood. The developers promised great neighbors and set aside a portion of the tract for commercial development. (Courtesy of the Santa Monica Land and Water Company Archives.)

TRACT MAP. Brentwood Place takes advantage of the existing Santa Monica street grid, lining its lots up on right angles to the numbered streets. According to this map, the street names between San Vicente Boulevard and Montana Avenue were Brentwood Terrace, Loomis Avenue, San Pablo Avenue, and Puente Avenue. For whatever reasons, the names were changed over the years to Georgina Avenue, Carlyle Avenue, and Marguerita Avenue. (Courtesy of the Santa Monica Land and Water Company Archives.)

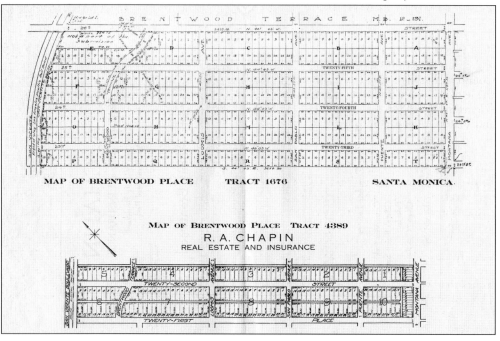

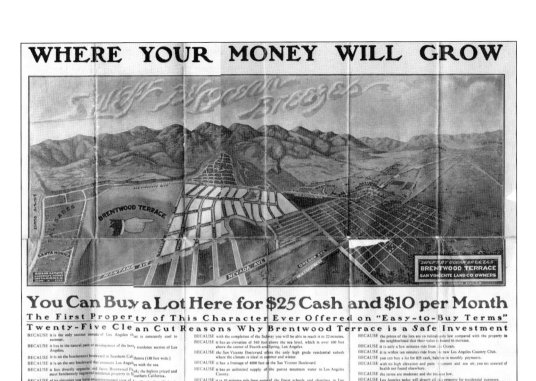

JUST A LITTLE DOWN. Brentwood Terrace advertised that a person could buy a lot for $25 down (in cash) and $10 per month. However, this is a ghost suburb. Most of the land that is shown as the subdivision in this brochure was never developed and became instead the Brentwood Country Club. Only two streets on the left side were actually developed. (Courtesy of the Santa Monica Land and Water Company Archives.)

PRICES, 1916. The brochure for Brentwood Terrace was marked with the prices of each lot. The lots closest to San Vicente Boulevard were the most expensive—$2,200 to $2,500. On the Montana Avenue edge, prices were in the $400 to $600 range. The darker areas were sold located on streets that were actually developed. The rest of the area became the club. (Courtesy of the Santa Monica Land and Water Company Archives.)

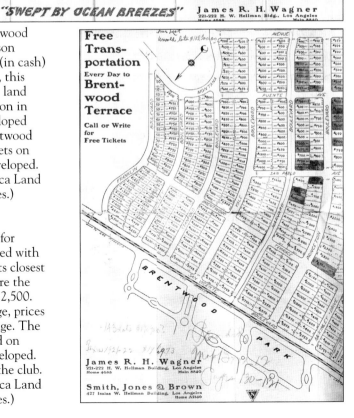

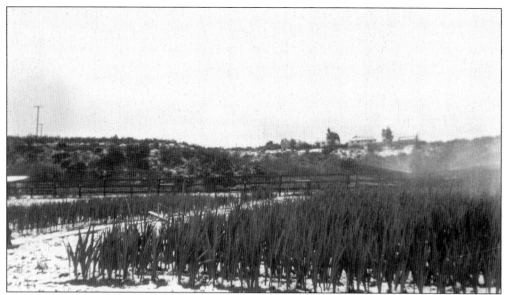

SULLIVAN CANYON. The open area at the intersection of Sullivan Canyon and Sunset Boulevard was used to grow gladiolas for the flower market for several years. This 1932 photograph was taken during a rare snowstorm that dumped several inches on the Brentwood area. The houses in the distance are on Rockingham Avenue in Brentwood Park. (Courtesy of the Santa Monica Land and Water Company Archives.)

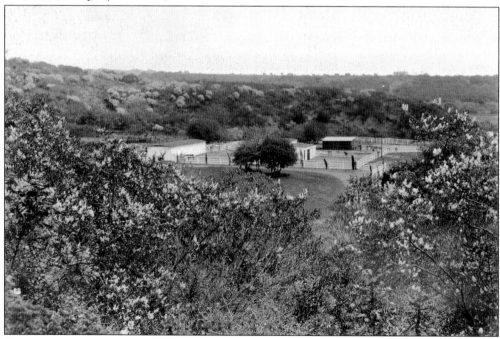

CEANOTHUS IN BLOOM. This photograph shows the hills of Sullivan Canyon covered with white ceanothus blooms. The buildings belong to the San Vicente Rancho stables that R. C. Gillis built for his daughter's show horses. The horses were walked up the canyon to San Vicente Boulevard, loaded on railcars, and shipped to horse shows. (Courtesy of the Santa Monica Land and Water Company Archives.)

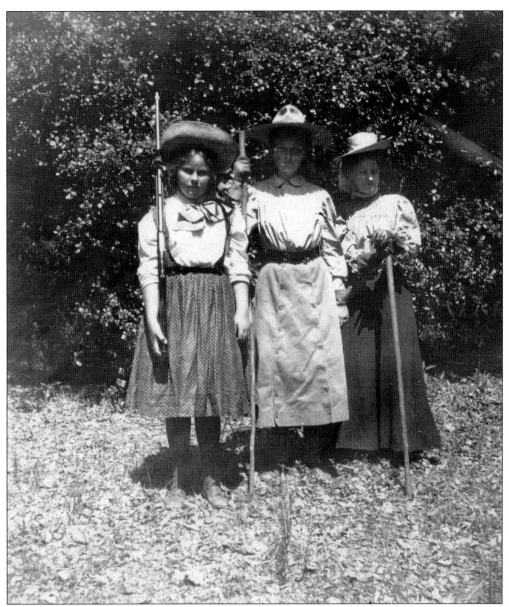

WALKING IN THE CANYON, 1910. From left to right, Dorothy Gillis, Adelaide Gillis, and Martha Freeman hike in Sullivan Canyon, a popular walking and hiking destination. Adelaide and Martha carry walking sticks while Dorothy carries a rifle. R. C. Gillis built a cabin there during the 1920s and used it as a retreat. Dorothy Gillis and her family lived in the canyon during World War II and raised their own food, livestock, and poultry. Sullivan Canyon was sold to Cliff May in the 1940s. May subdivided the area into horse properties and built many of his signature ranch houses there. There are still many stables in the area, and horses are a common sight. (Courtesy of the Santa Monica Land and Water Company Archives.)

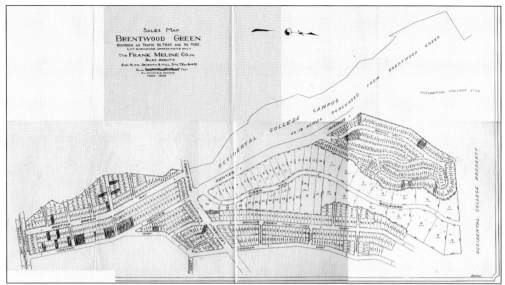

NORTH OF BEVERLY BOULEVARD. By 1924, Brentwood subdivisions were beginning to spread north into the hills above Beverly Boulevard (now Sunset Boulevard). Brentwood Green was planned with smaller lots along Gretna Green Way and Bowling Green Way. Larger lots were planned for Tiger Tail Boulevard. Today the area is usually called Kenter Canyon. Crestwood Hills, a neighborhood of mid-century modern homes, is at the top of Kenter Canyon Avenue. (Courtesy of the Santa Monica Land and Water Company Archives.)

TIGERTALES. In the 1920s, Occidental College was given land north of Beverly Boulevard by Alphonso Bell, and the college planned to build a campus there. All that remains of that idea is Tigertail Road, named for the Occidental mascot—a tiger named Oswald. The area was subdivided into homes after World War II. (Courtesy of the University of Southern California, on behalf of the USC Special Collections.)

Seven

THE RESIDENTS
LIVING IN BRENTWOOD

PICNICKING, 1898.
Before they were
subdivided for homes
and streets, the hills
and mesas around the
Soldiers' Home were a
favorite picnic destination
for the residents of
Santa Monica. This
group of women and
children found a shady
spot to pose for the
cameras. Adelaide Gillis
is the child on the left,
and her younger sister
Dorothy is on the right
standing next to her
grandmother, Mary
Clark Lindsey. The hats
ranged from bonnets to
stylish straw boaters and
the clothes were formal
even when picnicking.
(Courtesy of the Santa
Monica Land and
Water Company Archives.)

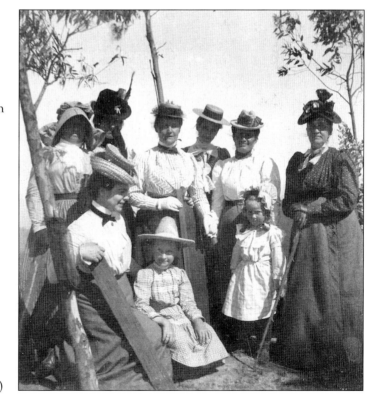

ENJOYING WESTGATE. By 1906, the Loomis home was beginning to look less like a new home in a new subdivision. The lawn was thriving, and the planting was beginning to grow up. The Cartercar has pride of place at the curb, and a bicycle leans against the front wall. L. D. Loomis lounges here with his dog. (Courtesy of the Santa Monica Land and Water Company Archives.)

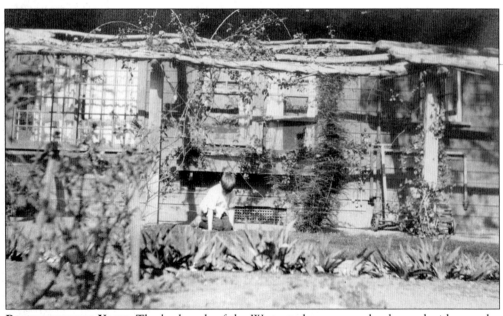

PLAYING IN THE YARD. The backyards of the Westgate homes were landscaped with pergolas and vines. There was still plenty of vacant land for the kids to explore and play games on after school. The new community built its first school in 1905, and the Santa Monica School System provided a teacher for the 20 children who lived in Westgate at that time. (Courtesy of the Santa Monica Land and Water Company Archives.)

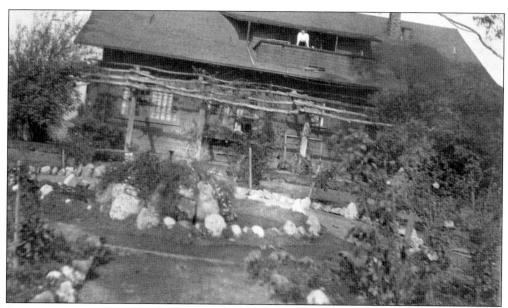

SURVEYING THE VIEW. Looking south from the second story of the Loomis home in 1906, Gracie Loomis would have had a view of the new streets and lots being graded out of the open bean and hay fields of the San Vicente Rancho. No doubt the rocks in her garden came from the land that was being cleared for the new residents. (Courtesy of the Santa Monica Land and Water Company Archives.)

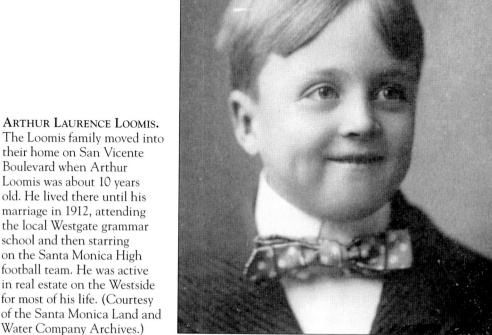

ARTHUR LAURENCE LOOMIS. The Loomis family moved into their home on San Vicente Boulevard when Arthur Loomis was about 10 years old. He lived there until his marriage in 1912, attending the local Westgate grammar school and then starring on the Santa Monica High football team. He was active in real estate on the Westside for most of his life. (Courtesy of the Santa Monica Land and Water Company Archives.)

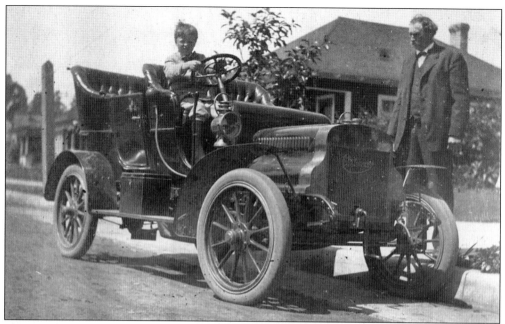

DRIVING LESSON. The Cartercar may have been one of the only automobiles on San Vicente Boulevard in 1906, but the new community was definitely being built for the automotive era. Wide, oiled streets were the norm, and even though they were unpaved, there were curbs. The Cartercar was manufactured until about 1916. The company was bought in 1909 by Pontiac and eventually became part of General Motors. (Courtesy of the Santa Monica Land and Water Company Archives.)

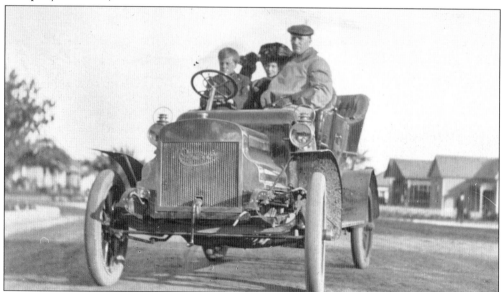

OUT FOR A SUNDAY DRIVE. Motoring in the early 1900s required holding on to your hat. The crank ignition system of the Cartercar is evident in this photograph. At this time, the Cartercar was considered the most successful car to use a friction transmission with infinitely variable ratios and few moving parts. It was advertised as the car with "a thousand speeds." (Courtesy of the Santa Monica Land and Water Company Archives.)

DRESSED FOR DRIVING. Hallie Bundy has tied her hat on her head in preparation for a motor trip. Gracie Loomis wears a duster, a necessary protection from dust and weather in the open cars of the day. A car is visible in the garage in the background with two children peering over the back end. (Courtesy of the Santa Monica Land and Water Company Archives.)

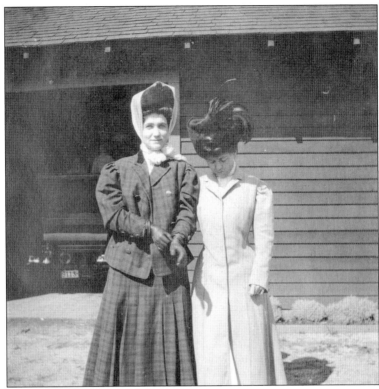

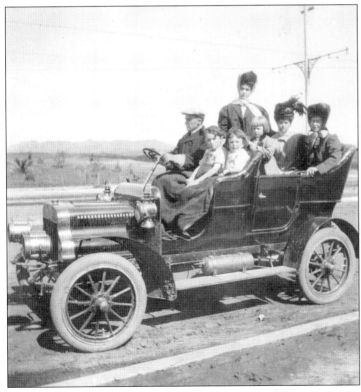

FAMILY AND FRIENDS. L. D. Loomis has piled children, his wife, his sister, and friends into the Cartercar for this photograph, probably taken by his brother-in-law C. L. Bundy. The distinctive iron scrollwork on the trolley poles along San Vicente Boulevard is visible in the background. Taken in front of the Loomis house looking north, nothing impedes the view of the hills. (Courtesy of the Santa Monica Land and Water Company Archives.)

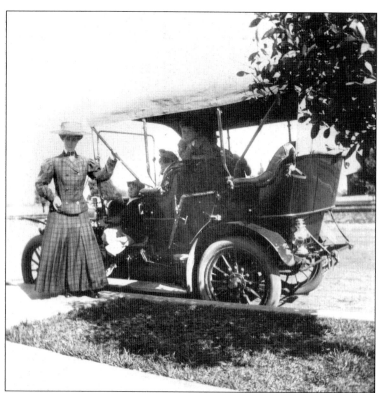

THE WINTON TOURING CAR. C. L. Bundy and his wife, Hallie, lived in early Westgate, and they owned this Winton automobile. Hallie poses beside it while her children, Douglas and Robert, and Leroy Loomis climb around the inside. Used for the first cross-country trip made by automobile, the Winton was considered a very sturdy vehicle, which was an advantage on the unpaved roads of the day. (Courtesy of the Santa Monica Land and Water Company Archives.)

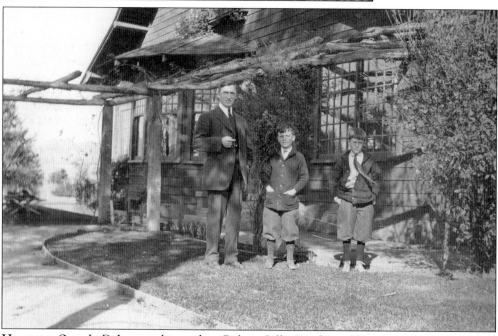

HANGING OUT. L. D. Loomis, his nephew Robert Gillis Bundy, and his younger son Leroy pose for this c. 1908 photograph, taken at the side of the Loomis house in Westgate. The boys wear knickers, sweaters, and ties. Loomis holds a cigar. (Courtesy of the Santa Monica Land and Water Company Archives.)

CHRISTMAS MORNING IN WESTGATE. The Loomis and Bundy families pose on Christmas morning. The children are showing off a new train and drum. Pictured here are, from left to right, (first row) Leroy Loomis, Arthur Loomis, unidentified child, Robert Bundy, and Douglas Bundy; (second row) two unidentified women, Gracie Loomis, an unidentified man, Hallie Bundy, Harriet Bundy, and Nathan Bundy. (Courtesy of the Santa Monica Land and Water Company Archives.)

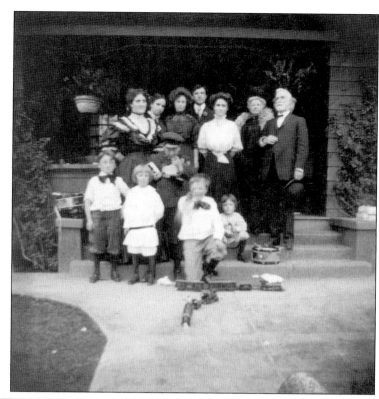

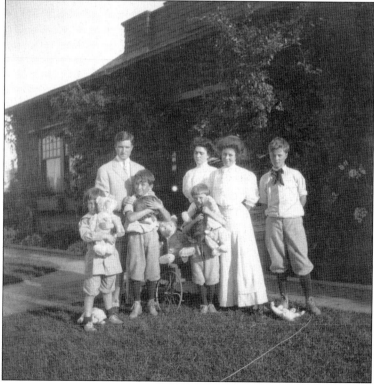

TEDDY BEARS AND CATS. The Bundy children are holding their favorite pets—Douglas his cat and Robert a large teddy bear. At this time, the teddy bear, named for Pres. Theodore Roosevelt, was a new toy. Pictured here are, from left to right, (first row) Leroy Loomis, Douglas Bundy, and Robert Bundy; (second row) unidentified, Hallie Bundy, Gracie Loomis, and Arthur Loomis. (Courtesy of the Santa Monica Land and Water Company Archives.)

ON THE PORCH. Nathan and Harriet Bundy rock on their porch in Westgate. Bundy lived in Westgate until his death in 1913. Many early accounts of Brentwood mention the ocean breezes and the good weather. (Courtesy of the Santa Monica Land and Water Company Archives.)

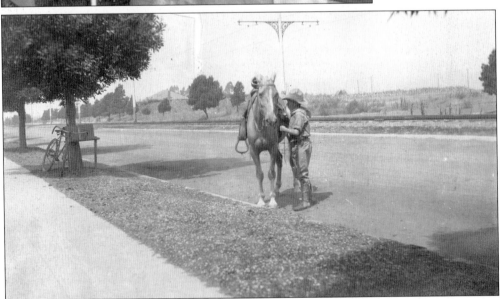

SADDLE UP. The automobile and the bicycle may have been the hot new toys in Westgate, but the horse was still the transportation mainstay. The children all had ponies and rode them to school and for fun. According to Arthur Loomis, a favorite game was to "chase the girls with the ponies and make them squeal." (Courtesy of the Santa Monica Land and Water Company Archives.)

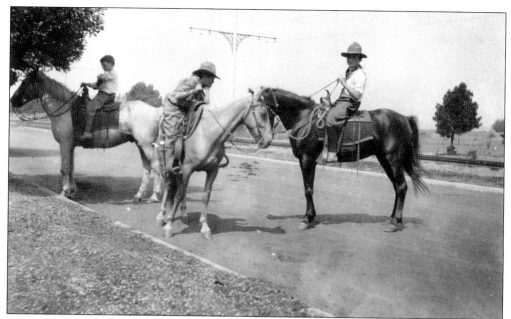

LARKING AROUND. From left to right, Leroy Loomis, Robert Bundy, and Douglas Bundy pose with their ponies on San Vicente Boulevard. They were cousins and all attended the Westgate school. Seventy-five years later, Arthur Loomis remembered some of the names of their classmates—Herbert Davis, Joseph Davis, Wilson Clarlson, Dole McNary, Elsie Schilling, Seth Gidley, and Helen Knapp. (Courtesy of the Santa Monica Land and Water Company Archives.)

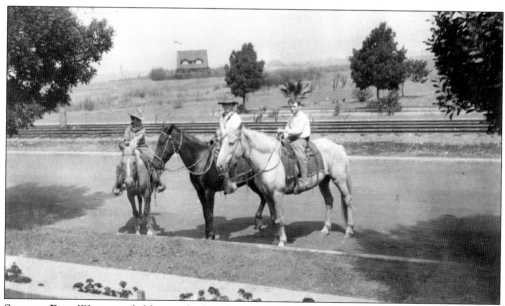

SCHOOL BUS. Westgate children rode their horses or bicycles to the school on Gretna Green. The school had a shed for the ponies and bicycles as well as two outhouses. The first teacher was Miss Rowland. C. L. Bundy gave the land for the school, and the property owners built it. (Courtesy of the Santa Monica Land and Water Company Archives.)

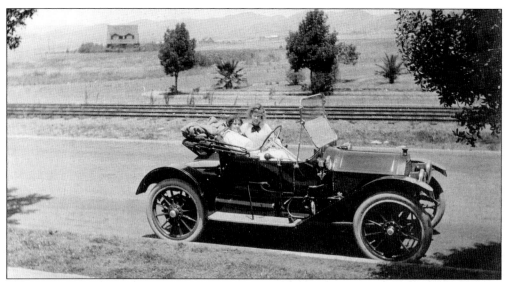

FIRST CAR, 1911. Ynez Ward, the niece of Arcadia Bandini de Baker, shows off her brand new roadster to Gracie Loomis. The wheel is still on the right side of this car even though manufacturers were already changing to left-hand drive by this time. Ynez Ward married Arthur Loomis. Note that houses are now built north of San Vicente Boulevard. (Courtesy of the Santa Monica Land and Water Company Archives.)

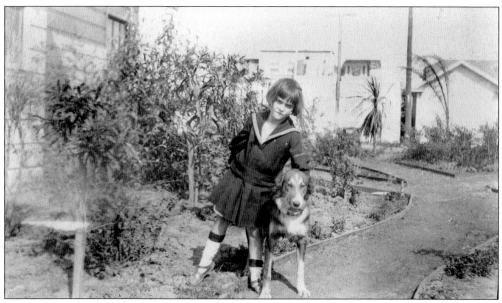

ANOTHER GENERATION. Margaret Ynez Loomis was born in her grandparents' home in Westgate in 1913. Her parents were Arthur and Ynez Loomis. This photograph, taken at the side of the house around 1920, shows how much Westgate has grown. The open fields where her father rode his pony are gone, replaced by homes. (Courtesy of the Santa Monica Land and Water Company Archives.)

THE HOLLYWOOD CONNECTION. The weather and the scenery of the west side were perfect for movies. The Vitagraph Company actually leased a portion of Rustic Canyon so that they could use the hills behind Brentwood as backdrops for Westerns. Movie stars working on those pictures quickly discovered that Brentwood was a great place to live. This postcard depicts Gary Cooper's home in Brentwood Heights. (Courtesy of the Santa Monica Land and Water Company Archives.)

CAROLE LOMBARD. This exterior view of the movie star's home was taken in 1935. Lombard was carrying on an affair with Clark Gable at the time. The couple bought a ranch in the San Fernando Valley after they married in 1939. (Courtesy of the Security Pacific/Los Angeles Public Library.)

CLARK GABLE. Prior to his marriage to Carole Lombard, Gable lived in this home at 200 Bentley Avenue. Postcard packs showing the movie star homes were printed and sold to tourists. (Courtesy of the Santa Monica Land and Water Company Archives.)

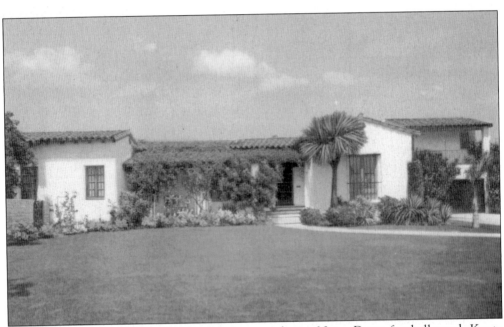

PAT O'BRIEN. One of his most famous roles was playing Notre Dame football coach Knute Rockne in *Knute Rockne, All American* in 1940, making "Win one for the Gipper" a line that went into movie and sporting lore and became a cliché. O'Brien built his reputation on playing bluff Irishmen, often priests. There were and are so many movie stars living in Brentwood that residents tend to respect their privacy and ignore them. (Courtesy of the Santa Monica Land and Water Company Archives.)

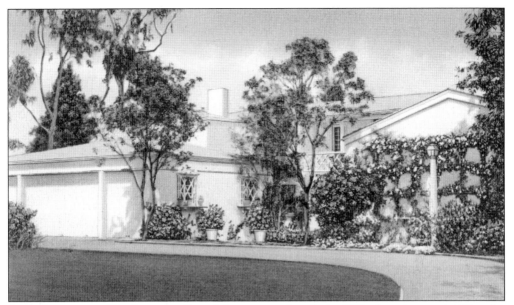

JOAN CRAWFORD. This house on Bristol Avenue was bought in 1929 when she married Douglas Fairbanks Jr., and it remained Crawford's residence until the 1960s. She married and divorced several husbands after Fairbanks while living here. (Courtesy of the Santa Monica Land and Water Company Archives.)

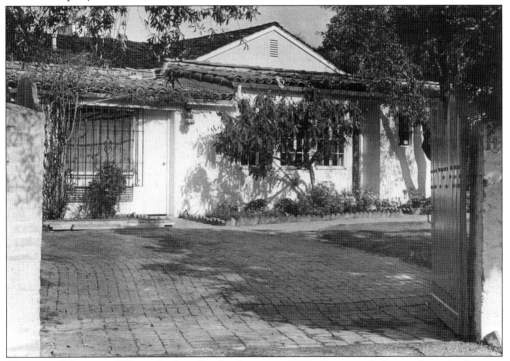

MARILYN MONROE. When she bought this home in 1961, she named the modest, single-story home on Helena Drive "Cursom Perficio," which means "My journey is complete," an eerie precursor of what came next. Monroe committed suicide in this home in 1962. *(Courtesy of the Herald-Examiner Collection/Los Angeles Public Library.)*

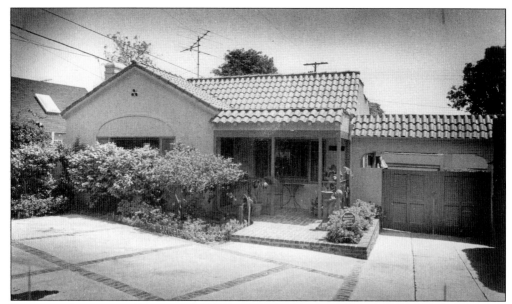

RAYMOND CHANDLER. Not every famous person who lives in Brentwood is or was a movie star. Authors, screenwriters, composers, and politicians like Gov. Arnold Schwarzenegger and Los Angeles mayor Richard Riordan also live there. Raymond Chandler taught himself to write pulp fiction and often used Los Angeles as the setting for his novels. (Courtesy of the Herald-Examiner Collection/*Los Angeles Public* Library.)

O. J. SIMPSON. Perhaps Brentwood's most infamous resident is shown here carrying the Olympic torch through Santa Monica in 1984. Simpson's wife was murdered along with Ron Goldman on the doorstep of her condominium on South Bundy Drive near Dorothy Street. Simpson lived on North Rockingham Avenue. The notoriety around his trial and acquittal gave Brentwood more publicity than it needed or wanted. (Courtesy of the Herald-Examiner Collection/*Los Angeles Public* Library.)

Eight

THE INSTITUTIONS
SERVING BRENTWOOD

THE LOS ANGELES NATIONAL CEMETERY. The first burial in the newly established "bivouac of the dead" took place on May 1889. Located on the eastern edge of the Soldiers' Home property, the cemetery has grown from its original 20 acres to its present 114 acres. The granite obelisk visible in this souvenir postcard was erected on San Juan Hill in "Memory of the Men Who Offered Their Lives in Defense of Their Country." There are 14 Medal of Honor winners buried in the cemetery. There are also two dogs buried here—Bonus, the pet of the residents at Soldiers' Home, and Blackout, a war dog wounded in World War II. The gate depicted no longer exists. (Courtesy of the Brentwood Historical Society.)

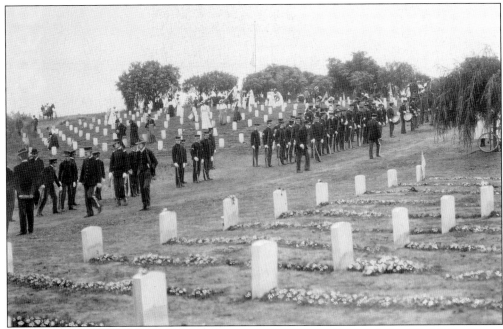

DECORATION DAY, 1905. Memorial Day (known as Decoration Day until after World War II) was established in the 1860s to honor Union soldiers who died in the Civil War. In this photograph, the graves in the foreground are decorated with flowers, and the patients are gathering for a ceremony to honor their comrades. The band is being inspected at left, and visitors are placing flowers in the background. (Courtesy of the University of Southern California, on behalf of the USC Special Collections.)

HOLLYWOOD MILITARY ACADEMY. In the 1920s, the Hollywood Military Academy educated many of the children of Brentwood on its campus at the corner of Cliffwood Avenue and San Vicente Boulevard. In addition to military drills, the boys participated in a number of activities, including a football team and debate team. The school closed soon after the death of its headmaster in 1934. (Courtesy of the Santa Monica Land and Water Company Archives.)

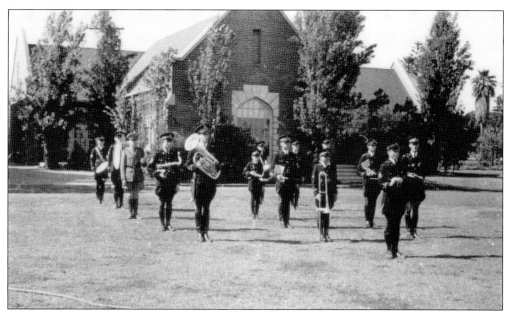

STRIKE UP THE BAND. The drum and bugle corps of the Hollywood Military Academy is formed up on the parade ground of the school. The school hosted dances for the local teenagers that are still fondly remembered. Students included the Douglas children and the stepson of Edgar Rice Burroughs. The faculty organized Troop 60, Crescent Bay Council, Boy Scouts of America in 1933. The scouts went on an outing once a month. (Courtesy of the Santa Monica Land and Water Company Archives.)

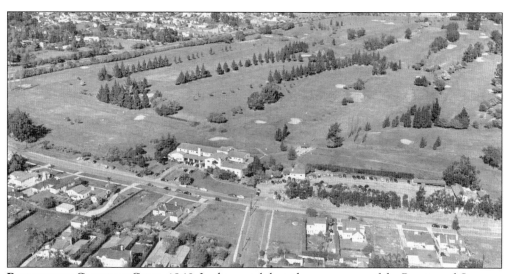

BRENTWOOD COUNTRY CLUB, 1949. In this aerial shot, the open space of the Brentwood Country Club stands out in contrast to the rapidly developing neighborhoods. The original site for the club was across San Vicente Boulevard in the Brentwood Park area. Its current site was originally scheduled to be developed as Brentwood Terrace. However, by the late 1920s, the club is listed as the owner of the site on the tract maps. (Courtesy of the Brentwood Country Club.)

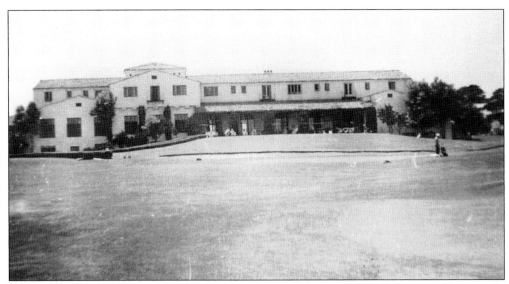

CLUBHOUSE ENTRANCE, 1948. The club had a number of owners over the years and was nearly sold for subdivision in 1949. However, local developers Edward Zuckerman and Arthur Edmunds purchased the property so that it could be maintained it as a private country club. (Courtesy of the Brentwood Country Club.)

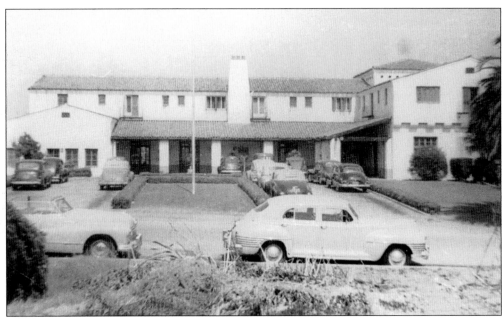

CLUBHOUSE REAR, 1948. The architecture of the clubhouse is Southern California Spanish. It has been remodeled a number of times, but the original clubhouse is still part of the structure. The club is a welcome spot of green in the Brentwood area when glimpsed through it high walls of greenery. (Courtesy of the Brentwood Country Club.)

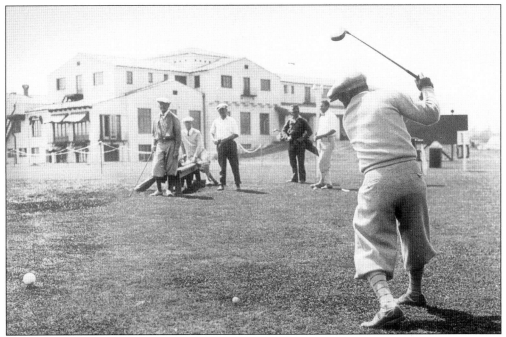

GOLFING IN 1940. Golfers are nattily dressed in knickers and argyle socks as they tee off in front of the Brentwood Country Club clubhouse. Note there are no golf carts in sight. (Courtesy of the Santa Monica Public Library Image Archives.)

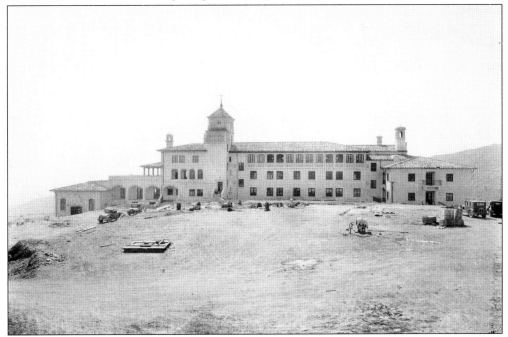

MOUNT ST. MARY'S COLLEGE. Construction is underway on the new college campus site purchased in 1928. The college was founded in 1925 by the Sisters of St. Joseph of Carondelet. The college's original purchase of Brentwood land was 33 acres at a cost of $4,500 an acre. There was no road when they first saw the site, but plenty of rattlesnakes. (Courtesy of Mount St. Mary's College.)

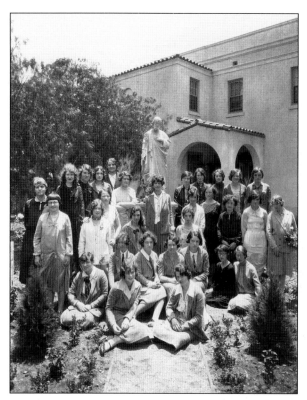

THE FIRST STUDENTS. Mount St. Mary's College is the only Catholic college primarily for women in the Western United States. The Chalon campus above Brentwood offers a traditional baccalaureate degree program with a strong emphasis on social and ethical values. The first class graduated in 1929, and the campus was dedicated at the same ceremony. (Courtesy of Mount St. Mary's College.)

THE LIBRARY. When Brentwood became part of Los Angeles, it became eligible for city services. The Los Angeles Public Library established a station in a rented room on Montana Avenue in 1923. The Westgate Improvement Association paid the bills. This photograph shows the library location during the 1920s. (Courtesy of the Security Pacific Collection/Los Angeles Public Library.)

STOREFRONT BOOKS. In the 1930s, the library station was located alongside the hardware store on San Vicente Boulevard. It was located there for about 10 years, paying $50 a month in rent. When the landlord raised the rent in 1946, the library was closed for lack of funds. For two years, the growing community did not have a library. (Courtesy of the Security Pacific Collection/Los Angeles Public Library.)

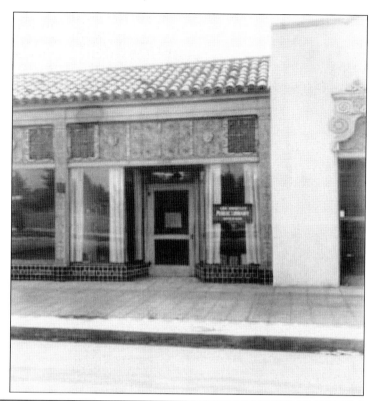

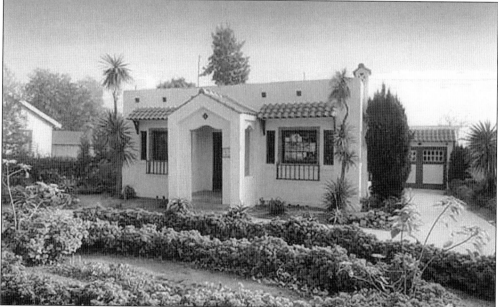

HORCH COTTAGE. In 1948, Jacob A. Horch donated his home located on San Vicente Boulevard to the Los Angeles Public Library as a site for a library station. The cottage was gratefully accepted, and the library opened in the Horch Cottage two months after the offer was made. A new structure replaced the cottage in 1960, and the library station officially became a branch. (Courtesy of the Security Pacific Collection/Los Angeles Public Library.)

BRENTWOOD PRESBYTERIAN CHURCH. In 1924, a group of parents decided to start a Sunday school for the children of Westgate. By 1929, the founders were ready to become a full-fledged church and the Community Church of Brentwood Heights became a reality. It was officially a branch of the First Presbyterian Church of Santa Monica. The rent was $35 for a building located at Gorham and Granville Avenues. The church moved to its current site at the corner of San Vicente Boulevard and South Bundy Drive in 1935. (Courtesy of the Brentwood Presbyterian Church.)

FAMOUS WEDDINGS. Brentwood's many celebrities are often seen in local churches, markets, and other sites. Here Jimmy Stewart and Gloria McLean are leaving Brentwood Presbyterian Church after their wedding in 1949. (Courtesy of the Department of Special Collections, Charles E. Young Research Library, UCLA.)

EXPANDING AND FLOURISHING. Brentwood Presbyterian Church continued to flourish and by 1948 needed to expand it facilities. This drawing shows the projected additions and changes to the church. Today the church is a thriving facility with over 750 members. (Courtesy of the Brentwood Presbyterian Church.)

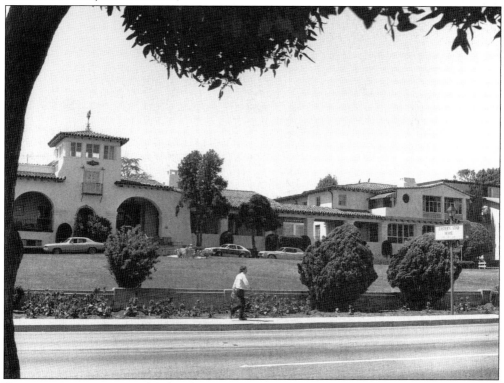

EASTERN STAR HOME. A landmark on Sunset Boulevard and currently housing the Archer School for Girls, the Eastern Star Home was built in 1931. It is a perfect example of the Spanish colonial Revival style, designed by California architect William R. Mooser. The retirement facility was operated by the Order of the Eastern Star for exemplary members of the order. (Courtesy of the Security Pacific Collection/Los Angeles Public Library.)

ST. MARTIN OF TOURS. Brentwood's catholic parish was established in 1946. The church was built and dedicated in 1947. The school was built in 1954 and staffed by the Sisters of St. Joseph of Carondelet, the same order that runs Mount St. Mary's College in the hills above St. Martins. Ricky Nelson and his new wife, Kristin Harmon, are shown here leaving the church after their wedding in 1963. (Courtesy of the Department of Special Collections, Charles E. Young Research Library, UCLA.)

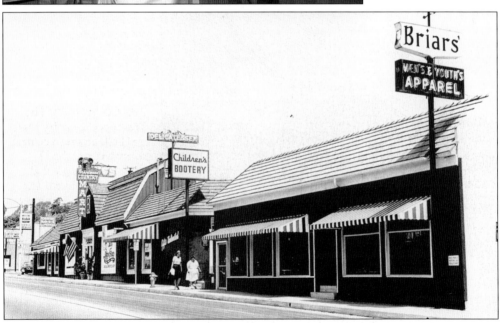

BRENTWOOD COUNTRY MART. Land was set aside on Twenty-sixth Street for commercial development when Brentwood Place was subdivided in the 1920s. Brentwood Country Mart was developed in 1948 on the land to resemble a country marketplace. Designed by architect Roland Crawford, the red-board structure quickly became a community landmark. (Courtesy of J. S. Rosenfield and Company.)

CELEBRITY SHOPPING. Shirley Temple Black shops with her daughter at the Brentwood Country Mart. The mart has long been a popular place to spot movie stars. Black lived on Rockingham Avenue when she was growing up and attended Westlake School for Girls. Many movie stars were regulars at the mart—Elizabeth Taylor, Burt Lancaster, and Greta and Gregory Peck were all known to shop here. (Courtesy of J. S. Rosenfield and Company.)

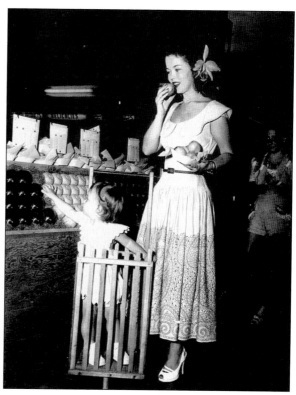

THE COURTYARD. The Brentwood Country Mart was built around a central courtyard and the 27 shops were designed to open into this area. The tables are a favorite place for Brentwood residents to grab lunch or feed the children after a soccer match. There was a post office, a shoe repair shop, and a barbershop among the original tenants. Marjans and the Reddi Chick (one of the original tenants) have provided many a picnic and beach feast. (Courtesy of J. S. Rosenfield and Company.)

95

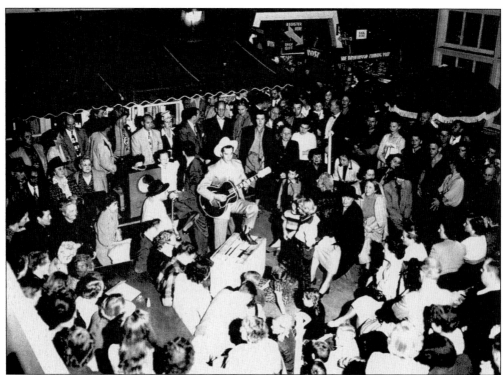

COMMUNITY CENTER. The mart's promotion program stressed community events and soon Brentwood groups and clubs were meeting there. Birthday parties were a regular occurrence. The first anniversary was marked by a party that featured a Western band and a number of celebrities. (Courtesy of J. S. Rosenfield and Company.)

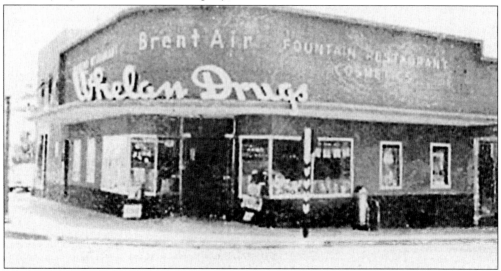

BRENTWOOD VILLAGE. In 1951, when Harold Lassoff opened his Whelan Pharmacy, the area at Sunset Boulevard and Barrington Avenue was already a small village. There was a beauty parlor; the Parasol Bakery, known for its cakes; two gas stations; and two dry cleaners. Brentwood Military Academy was on the corner, and cadets often paraded on the football field at the corner of Sunset Boulevard. (Courtesy of Harold Lassoff.)

EVANS AND REEVES. Once there were a number of nurseries in Brentwood. Evans and Reeves was located on Barrington Avenue near Brentwood Village until the late 1950s. Hugh Reeves was famous for his gardening skills and started his nursery in 1936. The coral trees that are planted on San Vicente Boulevard came from his garden. All that remains of the nursery is a large coral tree south of the post office. (Courtesy of the Santa Monica Land and Water Company.)

Crestwood Hills Nursery School

This is to certify that

Jody Kaufer

has completed the Nursery Years and is hereby graduated with honors

This 17th day of July 1959

Emma Cooder
DIRECTOR

Kit Anderson
TEACHER

Marjorie Braude
PRESIDENT

CRESTWOOD HILLS NURSERY SCHOOL. The Crestwood Hills cooperative settlement was formed in 1946 by a group of friends who decided to pool their resources and purchase land. The land was purchased in 1948 in the hills above Sunset Boulevard. There were 500 families in the original group. In addition to a collection of strikingly modern homes, the association created a credit union and a cooperative nursery. The nursery is still going strong. (Courtesy of Lise Selesnick.)

TUMBLEWEED DAY CAMP. The camp was established in 1954, and generations of Brentwood children have attended the sessions over the years. Situated on 100 acres in the Santa Monica Mountains, the camp introduces children to swimming, rock climbing, arts and crafts, and nature study. (Courtesy of Tumbleweed Day Camp.)

HORSEBACK RIDING. Horses have always been a part of Brentwood. Early on, most of the children had ponies in their backyards and rode them everywhere. As the automobile took over the area, horses became a rarity. Now Tumbleweed Day Camp is one of the only places for the young horseback rider to practice. (Courtesy of Tumbleweed Day Camp.)

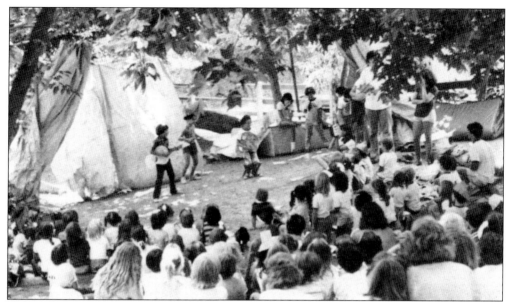

CAMP FIRES AND TALENT SHOWS. Once the children of Brentwood could camp and roam the hills without seeing a soul. Today these activities are restricted to the Santa Monica Park and Tumbleweed Day Camp. Here a couple of would-be rock stars entertain the campers. (Courtesy of Tumbleweed Day Camp.)

DUTTON'S BRENTWOOD BOOKS. Most communities have lost their independent bookstores, so Brentwood is lucky to have a thriving bookseller. Dutton's opened in the 1980s and has been an institution ever since. Located in a landmark building on San Vicente Boulevard, the bookstore has a cafe and sponsors book groups and book signings. (Courtesy of Dutton's Brentwood Books.)

AUTHOR, AUTHOR. The interior courtyard of Dutton's is often used for al fresco speeches by authors. John Kerry addresses the crowd in this photograph. The Barry Building, which houses the bookstore, was built in 1950 and is a good example of mid-20th-century architecture. (Courtesy of Dutton's Brentwood Books/Diane Leslie.)

UNIVERSITY SYNAGOGUE. The synagogue was started in 1943 by five families who broke away from the Santa Monica traditional synagogue to create a reform congregation. The first building was on Gorham Avenue. The present building, located at the corner of Sunset Boulevard and Saltair Avenue, was started in 1955. The stained-glass windows that flank the ark were created by Perli Pelzig, a well-known Israeli artist and Holocaust survivor. The synagogue has been in the forefront of treating alcohol abuse. (Courtesy of University Synagogue.)

Nine

THE HAPPENINGS
MEMORABLE MOMENTS

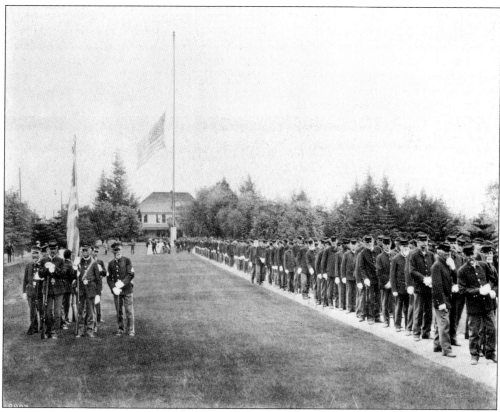

ON PARADE, 1905. Decoration Day (Memorial Day) was celebrated every May by the residents of the Soldiers' Home. Here the patients are lining up for a parade and the color guard is standing at left in the photograph. The flag at the center of the cemetery is at half-staff. (Courtesy of the University of Southern California, on behalf of the USC Special Collections.)

THE MEMORIAL DAY PARADE. For many years, Brentwood continued the tradition started by the early residents of the Soldiers' Home and held its own Memorial Day parade. The community lined up on San Vicente Boulevard to watch the vintage automobiles, the horses, the stagecoach, and local celebrities march down the boulevard. (Courtesy of Dick Thompson.)

VINTAGE CARS AND LOCAL HEROES. One of the rewards for being active in the Brentwood community was an honored place in the Memorial Day parade. Movie star residents and local luminaries shared the spotlight. Stan Lefcourt, who was active in almost everything in Brentwood for a number of years, rides in this vintage Thunderbird. (Courtesy of Dick Thompson.)

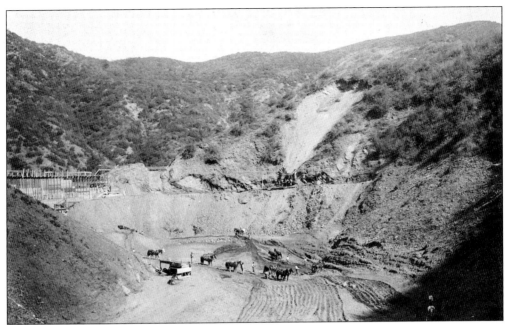

SEPULVEDA DAM, UNDER CONSTRUCTION. The Santa Monica Land and Water Company built a dam north of the Soldiers' Home near Sepulveda Pass to hold runoff and rainwater and provide emergency water for the home. The dam was constructed of earth and concrete around 1906. The construction crews are using horses and mules to clear the dirt and debris. (Courtesy of the Santa Monica Land and Water Company Archives.)

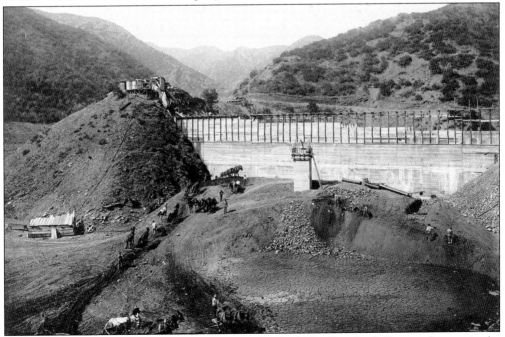

FINISHED. In this photograph, the dam is almost finished. The Sepulveda Pass can be seen in the background. The crews are still working on the face of the dam. (Courtesy of the Santa Monica Land and Water Company Archives.)

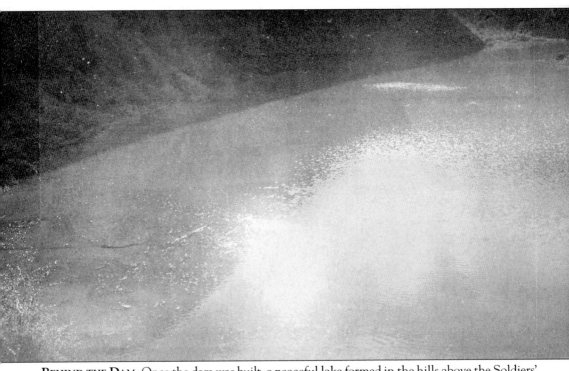

BEHIND THE DAM. Once the dam was built, a peaceful lake formed in the hills above the Soldiers' Home. The water in the dam was supposed to be used for emergencies such as fires and droughts.

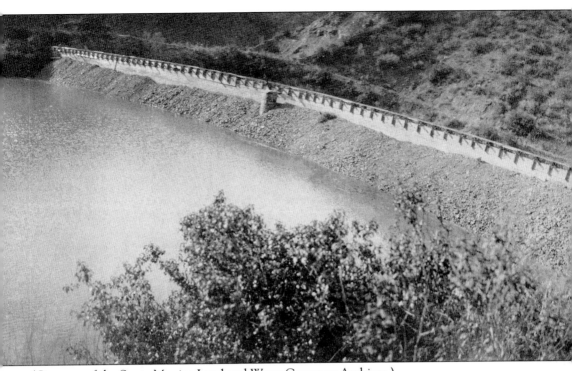

(Courtesy of the Santa Monica Land and Water Company Archives.)

SURVEYING. This photograph was probably taken at the same time as the one of the lake behind the dam. It shows the front of the dam and the amount of dirt that was moved to contain the water. The dam was abandoned around 1913 when it was deemed unsafe and a breach was made in the top, draining some of the water. (Courtesy of the Santa Monica Land and Water Company Archives.)

AND THEN IT RAINED. February 1914 was one of those years in California when the rain came down in torrents. The rains were so bad that 35 bridges were washed out and all social activity ceased in Los Angeles. The rains filled the dam and when the breach was not sufficient to drain it, the dam broke, sending a wall of water down the canyon into the Soldiers' Home. (Courtesy of the Santa Monica Land and Water Company Archives.)

DAM BREAK FROM THE SOUTH. The water rushed down the canyon wiping out everything in front of it. It rushed through the powerhouse and laundry at the Soldiers' Home and forced several people to run for their lives. The boilers in the powerhouse were buried in two feet of mud. The water continued down the canyon, flooding out Palms as well. (Courtesy of the Santa Monica Land and Water Company Archives.)

WATER DEVASTATION. The north wall was completely destroyed by the force of the water, which broke the concrete and moved all of the dirt in front of the wall. The concrete ended up downstream, and the water killed thousands of chickens and destroyed a walnut orchard. (Courtesy of the Santa Monica Land and Water Company Archives.)

107

MEASURING THE DAMAGE. This man is standing next to a piece of the concrete front of the dam that washed down the stream. Many small farms were damaged by the flood, and the executives of the Santa Monica Land and Water Company rode horseback from house to house paying the farmers for their losses. (Courtesy of the Santa Monica Land and Water Company Archives.)

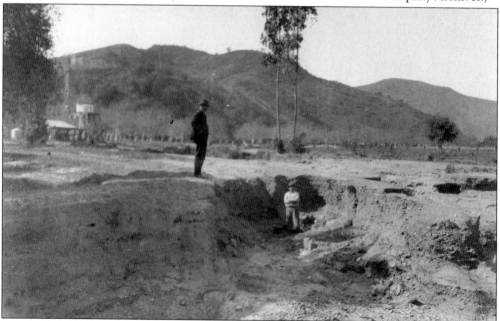

IN A HOLE. This man is standing in a hole gouged by the floodwater. It appears to be about six-feet deep. A water tank and a small shed are visible in the background. The men were apparently estimating how many loads of dirt it would take to fill the hole. (Courtesy of the Santa Monica Land and Water Company Archives.)

ORCHARD DAMAGE. The Jones walnut orchard produced walnuts for a number of nears next to the Soldiers' Home. The floodwaters rushed through it and ripped the trees out by their roots. (Courtesy of the Santa Monica Land and Water Company Archives.)

WAGON DISASTER. This farmer is apparently getting ready to dig his wagon out of the mud. The surviving walnut trees are behind him. Several lawsuits were filed after the dam break as people tried to recover from the damage. (Courtesy of the Santa Monica Land and Water Company Archives.)

BRENTWOOD GLEN. The walnut orchard apparently never recovered from the flood damage, and in the 1920s, the land was sold to the Ratteree brothers. The four brothers subdivided the land into Brentwood Glen, bounded on two sides by the Soldiers' Home and now by the I-405 freeway. The first home was built in 1932. (Courtesy of the Santa Monica Land and Water Company Archives.)

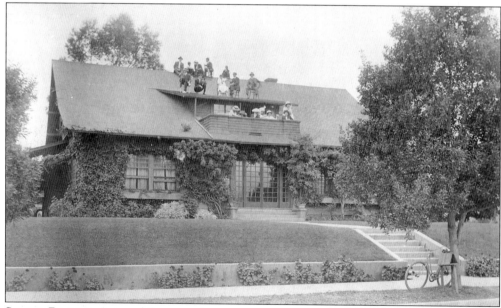

STREET RACING. Automobiles were always an important part of life in Brentwood. There were several automobile dealers in Santa Monica, and private cars were proliferating in the early 1900s. With the construction of San Vicente Boulevard, Nevada Avenue (now Wilshire Boulevard), and Ocean Avenue, a three-sided course for road racing was created. The first races were held in 1909, and a house on San Vicente Boulevard guaranteed a prime seat for the show. (Courtesy of the Santa Monica Land and Water Company Archives.)

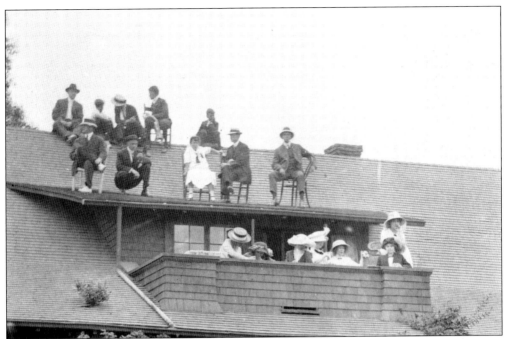

ROOF GAZING, A CLOSER LOOK. Spectators gathered on the roof of the L. D. Loomis house to watch the road races. The men seemed to have been allocated the roof while the women sit on the porch. The police estimated that 50,000 people were in attendance in 1912. (Courtesy of the Santa Monica Land and Water Company Archives.)

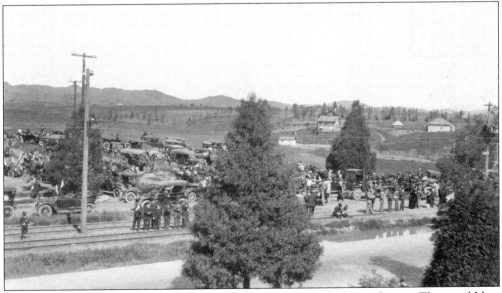

SPECTATORS. People came from all over Los Angeles to watch the road races. They could buy tickets for the grandstands on Ocean Avenue, or they could watch free on Nevada Avenue or San Vicente Boulevard. In this photograph taken from the house roof across the street, spectators have parked on the road and in the open fields. There are a variety of cars and even a flatbed truck loaded with people who have come to watch. (Courtesy of the Santa Monica Land and Water Company Archives.)

SPEED DEMONS. The blur in this photograph is a racecar going by; the camera was not fast enough to catch the visual. The spectators in the foreground are watching it speed by. These cars were the fastest available, and the winners were clocked at over 60 miles per hour on the straightaway. (Courtesy of the Santa Monica Land and Water Company Archives.)

THE CROWD. Note the cameraman in the white suit in the left foreground. Local businessmen and the Santa Monica auto dealers sponsored the races as a promotion for the area and their services. There were no rules; they made them up as they went along. Race cars were specially designed for the races, and drivers came from all over the country to compete. (Courtesy of the Santa Monica Land and Water Company Archives.)

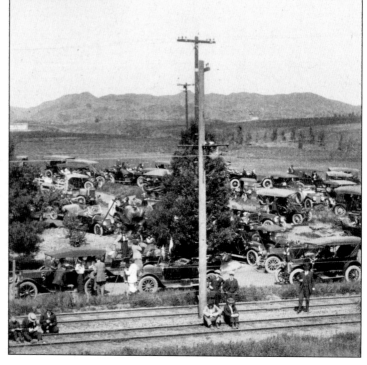

NEVADA AVENUE. In 1912, the spectators were 10 deep along Nevada Avenue, and the excitement was tremendous. This car is going fast enough to blur the camera. The success of the 1912 races led to Santa Monica being selected for the prestigious Vanderbilt Cup races. Santa Monica hosted the cup three times—in 1914, 1916, and 1919. (Courtesy of the Santa Monica Library Images.)

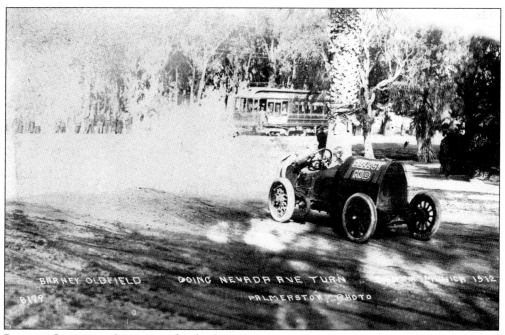

BARNEY OLDFIELD. Competing for the first time in Santa Monica, Barney Oldfield rounds the Nevada Avenue curve during the 1912 race. As No. 22, he drove a Fiat called the "Select Kid." Oldfield finished the race 45 minutes behind the winners thanks to several mechanical issues. (Courtesy of the Santa Monica Land and Water Company Archives.)

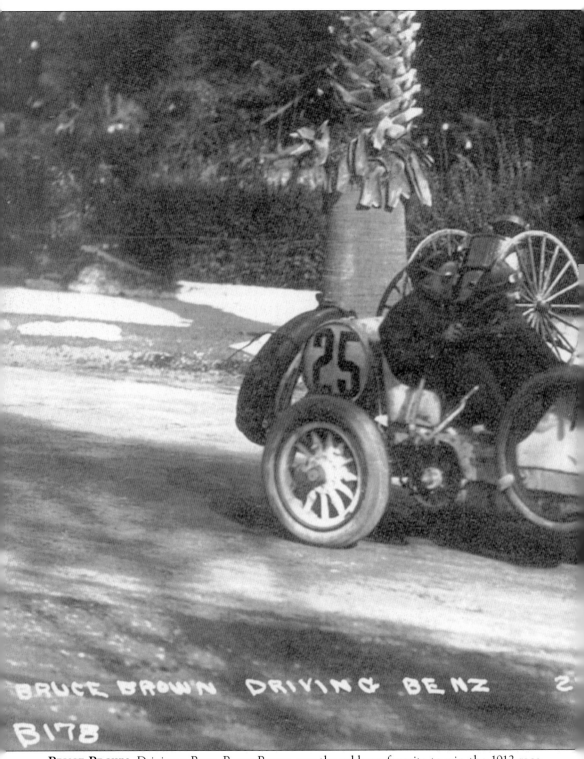

BRUCE BROWN DRIVING BENZ

B178

BRUCE BROWN. Driving a Benz, Bruce Brown was the odds-on favorite to win the 1912 race. Brown had already won several races and had a big reputation. However, Ted Tetzlaff won the

TA MONICA ROAD RACE 1912
PALMERSTON PHO.

race, and Brown came in third. Sadly, Brown was killed in another race several months later. (Courtesy of the Santa Monica Land and Water Company Archives.)

LOCAL WINNERS. Drivers like Barney Oldfield and Bruce Brown were from out of town, and the residents were rooting for the local drivers in 1912. They rejoiced when Santa Monica driver Ted Tetzlaff won the race. This photograph shows some of the detail of the race cars. (Courtesy of the Santa Monica Library Images.)

THE PITS. During the Vanderbilt Cup races in 1914, each of the teams had a marked pit for their support teams along Ocean Avenue. These spectators are sitting in the main grandstand with a clear view of the cars and Palisades Park. The road races were held in spite of a brush fire and the recent flooding. (Courtesy of the Santa Monica Library Images.)

OLYMPICS, 1932. The polo fields at the Uplifters Club were a popular attraction for residents and visitors. This 1927 match was well attended if the number of cars is any indication. These fields were used for the equestrian events at the 1932 Olympics in Los Angeles. Locals had boxes on the field or watched from the cheap seats along Rockingham Avenue, visible here in the background. (Courtesy of the Santa Monica Land and Water Company Archives.)

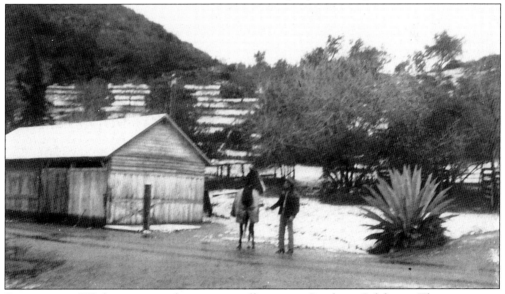

SNOWSTORM. While it is rare, it does occasionally snow in Southern California. This snowstorm in 1932 dropped enough snow on Brentwood to cancel schools and give the children a treat normally reserved for those living in colder climes. This photograph shows one of the horses from the Gillis stable and the snow on the hills surrounding Sullivan Canyon. (Courtesy of the Santa Monica Land and Water Company Archives.)

IT NEVER RAINS IN CALIFORNIA. In 1938, the rains came again and flooded a good portion of West Los Angeles. This sinkhole opened up on Sunset Boulevard between Sullivan and Mandeville Canyons. The water ran right across the polo fields and down Rustic Canyon, flooding out the mouth of Santa Monica Canyon. (Courtesy of the Santa Monica Land and Water Company Archives.)

FLOOD DAMAGE. The canyons above Brentwood tend to act like drains when it rains. This photograph shows the damage caused by the flood in Sullivan Canyon. The road was washed out, and many rocks were rolled down the hills. (Courtesy of the Santa Monica Land and Water Company Archives.)

THE BEACH COMBERS CAFÉ BURNS. Brentwood had its share of fires and accidents over the years. Located at the corner of San Vicente and Wilshire Boulevards, the Beach Combers Café burned on May 4, 1951. It looks like the cleanup has begun after the fire. (Courtesy of the University of Southern California Libraries, on behalf of the USC Special Collections.)

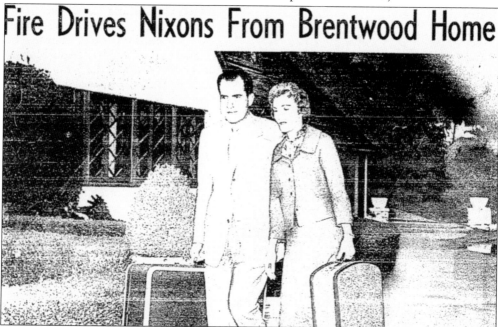

Fire Drives Nixons From Brentwood Home

NIXON FLEES FIRE. The Bel Air–Brentwood fire broke out in November 1961 and quickly became the biggest fire in Los Angeles history. Richard M. Nixon and his wife, Patricia, were living on North Bundy at the time while Nixon wrote his book *Six Crises*. He and his wife were evacuated although he did water his roof down before he was required to leave. (Courtesy of the *Los Angeles Times*, copyright 1961, reprinted with permission.)

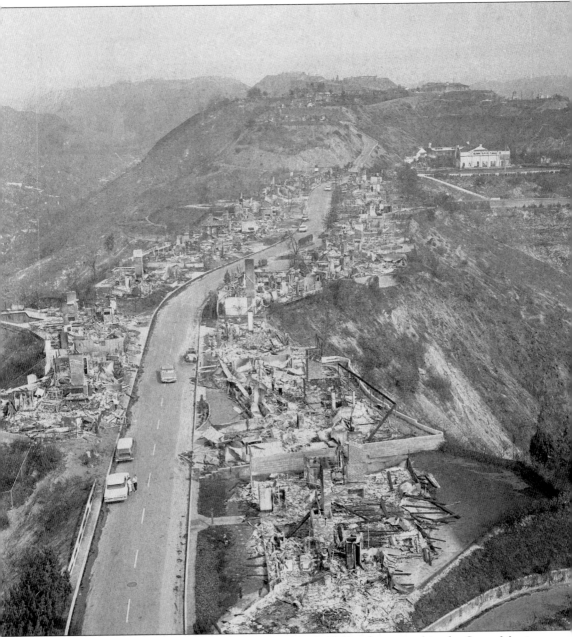

THE BEL AIR–BRENTWOOD FIRE. On November 6, 1961, a fire started in the Santa Monica Mountains and rapidly spread into the Bel Air–Brentwood area. The very high winds and dry conditions created a firestorm that burned everything in its path. Over 484 homes were destroyed, many of them belonging to celebrities—Joan Fontaine, Joan Davis, and Fred McMurray to name a few. Residents survey the devastation on Chalon Road after the fire. No houses were left standing. Mount St. Mary's College is visible in the right top of the photograph. (Courtesy of the Department of Special Collections, Charles E. Young Research Library, UCLA.)

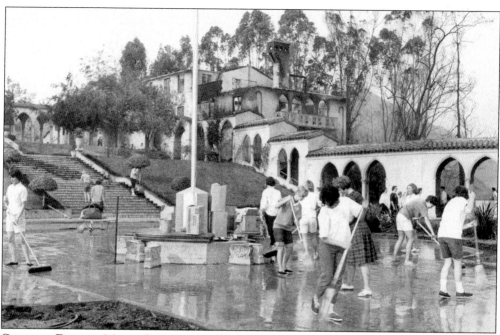

CLEANUP DETAIL. Mount St. Mary's College was saved from the Bel Air–Brentwood fire by a construction crew that had been working on the new I-405 freeway near the college. The fire had surrounded the school, and it looked like it would burn. However, the crews had water and equipment, and they used it to save the buildings. Here the students are washing the ash off the walks and cleaning up after the fire. (Courtesy Mount St. Mary's College.)

MURDER AND SUICIDE. Brentwood is normally a quiet safe neighborhood, but in 1966, Mickey Rooney's wife was found dead in her bed beside her lover. The case was ruled a murder-suicide. In this photograph, Rooney's children are being led out of the house by Harold Abeles. (Courtesy of the Department of Special Collections, Charles E. Young Research Library, UCLA.)

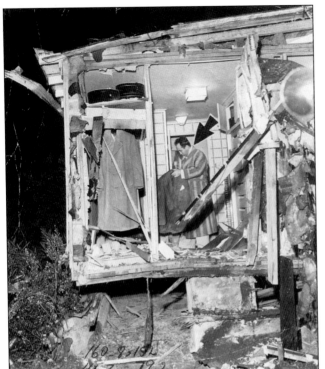

BOMBS AND GANGSTERS. Everyone knew that gangster Mickey Cohen lived in Brentwood, but normally he was a model citizen when he was in the area. However, in the 1970s, his life was threatened by a gang war and his home on Moreno Drive in Brentwood was bombed. He is seen here standing in the wreckage in his bathrobe. (Courtesy of the *Herald Examiner* Collection/Los Angeles Public Library.)

THE MISS BRENTWOOD PAGEANT. One of the community events that Brentwood residents enjoyed participating in was the Miss Brentwood Pageant. Local newscaster Paul Moyer and other celebrities were judges and local teenagers competed for prizes and scholarships. (Courtesy of Dick Thompson.)

Ten

TODAY

MOVING INTO TOMORROW

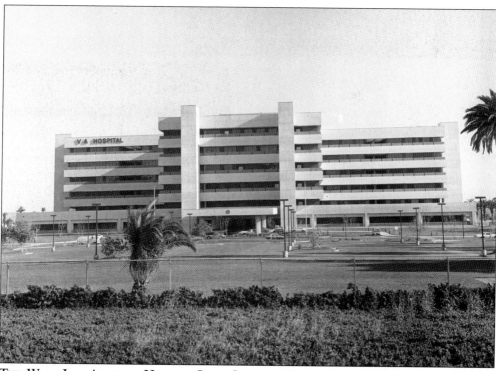

THE WEST LOS ANGELES HEALTH CARE CENTER. The Soldiers' Home has given way to a modern, state-of-the-art hospital that serves veterans from all over the Los Angeles area. A new facility for long-term care is under construction. The community continues to oppose any change in the status of the property, preferring that it be used for the health and well being of veterans instead of being sold for office buildings. (Courtesy of the Department of Special Collections, Charles E. Young Research Library, UCLA.)

THE KAUFMAN BRENTWOOD LIBRARY. The library has a brand new building constructed with money raised from the community and through the generosity of Glorya Kaufman's matching grant. The 10,040-square-foot building, named for Kaufman's husband Donald, opened in 1994. (Courtesy of the Donald B. Kaufman Brentwood Branch Los Angeles Public Library.)

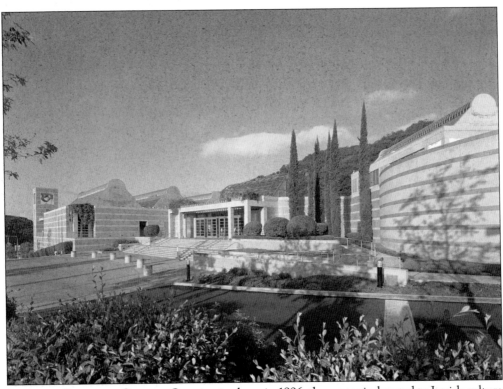

SKIRBALL CULTURAL CENTER. Opening its doors in 1996, the center is devoted to Jewish culture and heritage. Film events, changing exhibitions, and community and cultural programs are part of its community involvement. (Courtesy of Skirball Cultural Center.)

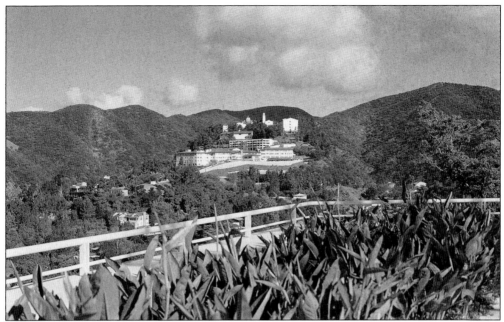

MOUNT ST. MARY'S COLLEGE. The college offers a dynamic learning environment for its students and is committed to providing liberal arts and science education to a diverse student body. It continues to improve its campus on the hill above Brentwood and is a vibrant part of the community. (Courtesy of Mount St. Mary's College.)

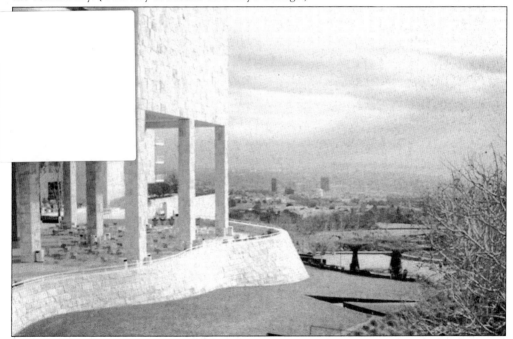

THE GETTY CENTER. Built high on the hill above Brentwood, the Getty Center is a cluster of striking buildings made of honey-colored stone and glass. The buildings have a 360-degree view of the city and Brentwood. The center is involved in important conservation work and also includes a world-class museum. (Courtesy of the Santa Monica Land and Water Company Archives.)

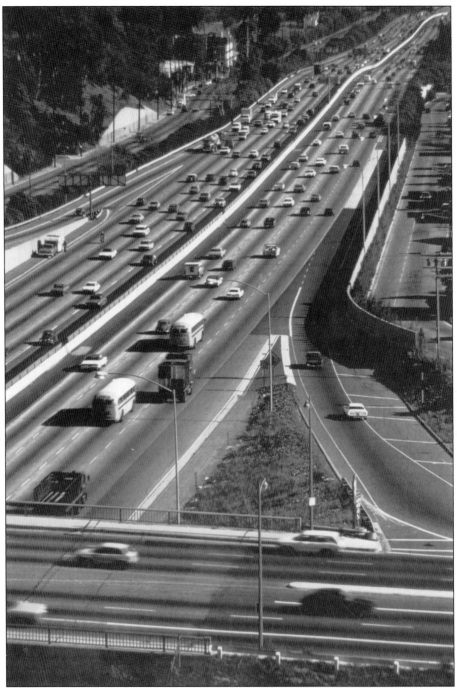

SUNSET BOULEVARD AT THE I-405, 1978. The freeway opened in the mid-1960s and gave Brentwood quicker access to downtown Los Angeles. While the freeway is a vital link for the residents of Brentwood, it is also a source of frustration with its sometimes overwhelming traffic. There are plans to widen the freeway, but the impact on Brentwood neighborhoods, especially Brentwood Glen, could be significant. (Courtesy of the Security Pacific Collection/Los Angeles Public Library.)

BIBLIOGRAPHY

Carrillo, Leo. *The California I Love*. Englewood Cliffs, NJ: Prentice-Hall, Inc., 1962.

Drinkwater, Judy, and Jan Loomis. *A Datebook for the Westsiders of Los Angeles—1982*. Los Angeles, CA: Santa Monica Bay Printing and Publishing Company, 1981.

Hendricks, William. *O. M. H. Sherman, A Pioneer Developer of the Pacific Southwest*. Corona del Mar, CA: The Sherman Foundation, 1973.

Ingersoll, Luther A. *Ingersoll's Century History Santa Monica Bay Cities*. Los Angeles, CA: Luther A. Ingersoll, 1908.

Los Angeles, From the Mountains to the Sea. Chicago and New York: The American Historical Society, undated.

Myers, William A., and Ira L. Swett. *Trolleys to the Surf: The Story of the Los Angeles Pacific Railway*. Glendale, CA: Interurbans Publications, Inc., 1976.

Newmark, Harris. *Sixty Years in Southern California, 1853–1913*. New York: The Knickerbocher Press, 1916.

Osmer, Harold, and Phil Harms. *Real Road Racing, The Santa Monica Road Races*. Chatsworth, CA: Harold L. Osmer Publishing, 1999.

White, Carl F., ed. *Santa Monica Community Book*. Santa Monica, CA: A. H. Cawston, 1953.

ACROSS AMERICA, PEOPLE ARE DISCOVERING SOMETHING WONDERFUL. *THEIR HERITAGE.*

Arcadia Publishing is the leading local history publisher in the United States. With more than 4,000 titles in print and hundreds of new titles released every year, Arcadia has extensive specialized experience chronicling the history of communities and celebrating America's hidden stories, bringing to life the people, places, and events from the past. To discover the history of other communities across the nation, please visit:

www.arcadiapublishing.com

Customized search tools allow you to find regional history books about the town where you grew up, the cities where your friends and family live, the town where your parents met, or even that retirement spot you've been dreaming about.

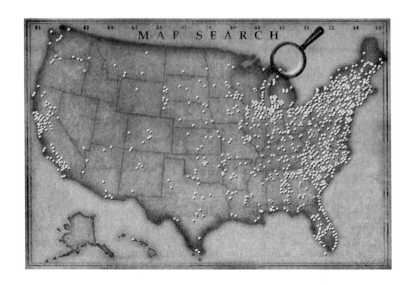

à vous LA FRANCE!

NOTES FOR TEACHERS

Bryan Howson

University of York

RADIO PRODUCER

Alan Wilding

TELEVISION PRODUCER

David Wilson

BBC BOOKS

A vous la France! is a combined BBC Television and Radio course for
beginners in French, first broadcast from October 1984.
It consists of:
15 television and 15 radio programmes running concurrently
One course book covering programmes 1–15
Two cassettes
One set of Notes for Teachers

Published to accompany a series of programmes in consultation
with the BBC Continuing Education Advisory Council

© The author and BBC Enterprises Limited 1984
First published 1984. Reprinted 1985 (twice), 1986, 1987, 1988, 1989 (twice),
 1990 (twice)
Published by BBC Books, a division of BBC Enterprises Ltd,
Woodlands, 80 Wood Lane, London W12 0TT
ISBN 0 563 21093 1

Filmset by Keyspools, Golborne, Lancs.
Printed and bound in Great Britain by Ebenezer Baylis and Son Limited,
The Trinity Press, Worcester, and London
Cover printed by Richard Clay Ltd, Norwich

Contents

Introduction

The course

A vous la France! is a multi-media French course for beginners comprising:
 i fifteen radio and fifteen television programmes based on short dialogues filmed or recorded in France with French people;
 ii an accompanying students' book which presents transcripts of the radio and television recordings with language notes, exercises, visual material and background information on France;
 iii two cassettes containing a selection of the broadcast recordings, together with pronunciation practice and exercises.

A vous la France! assumes no previous knowledge of French and no formal experience of foreign language learning. Its primary aim from the beginning is to teach the student to use the language actively in a wide range of social and transactional situations.

What the package cannot do, of course, is to deal with the students directly. Individual students will be looking for different things from the course and they will have their own particular areas of difficulty. The teacher should use *A vous la France!* as a base, enlarging on the material and instruction in the programmes and the course-book to meet the needs of each student as far as is possible. The purpose of these Notes is to suggest some ways in which this may be done.

Notes for Teachers

Each chapter of these Notes complements a chapter in the pupils' book and the relevant radio or TV programme. The learning aims of each chapter and programme are described, followed by suggestions for additional exercises and activities with which the teacher may reinforce and exploit the materials. There are more suggestions given than one could reasonably use in a two-hour session and teachers are advised to choose those ideas which best fit in with their own style and teaching methods and which they feel will work in the ethos of their particular classroom. It may be, too, that teachers will adapt a suggestion given in one chapter to apply to language points and situations which occur elsewhere in the course.

The principal aim of the Notes is to help teachers to present the wealth of material offered by this course in as lively and entertaining a fashion as possible. The learning process should be enjoyable and as individual as it can be – this is why language games are included as well as many activities which involve students working together, either in pairs or in groups.

The advantages of group work are that it increases the possibilities for each student to practise the language in a 'face-to-face' way; it encourages each student to adapt the 'model' language to his or her own

needs and opinions, thus bringing them closer to real communication in French; it can help build confidence since, in the early stages, some adults are nervous about expressing themselves before a whole room full of people; it also allows the student to feel that he or she is exercising some control over their learning and may remove some of the feeling of helplessness and frustration which mature learners can sometimes experience.

However, great delicacy and care need to be taken in forming pairs or groups. The teacher may, after discreetly observing the personalities and the natural social groupings in the class, suggest which two people, or group of people, should work together. It is often the case that the students will group or pair themselves quite naturally and amicably.

How large any group within the class should be depends to some extent on the nature of the activity to be undertaken, but generally four or five people working sociably together seems to be a good number. It is worth continuing to observe students during group or pair practice to check that they are working harmoniously and enjoying the activity – it may sometimes be necessary to intervene and make changes!

Working with adults

For the teacher working with adults learning a foreign language (perhaps for the first time) it is worth bearing in mind that even the most sophisticated and confident person – often having a responsible and influential role in their job or profession – can feel anxious at the moment when they return to the classroom. Some may recall their school experience as having been unsuccessful, boring and even humiliating. Many adults also approach language learning with the idea that it is very difficult, confusing and that they do not really have the gift for it.

The crucial role of the teacher from the beginning is to convince students that they are going to enjoy the classes, that they are going to succeed and that their dignity will not suffer.

The adult classes which work best are those with a teacher who takes trouble to create a relaxed, social atmosphere, who is approachable and who, above all, shows sensitivity in the way that he or she deals with students' errors. It is important, of course, to balance praise and encouragement of students' efforts with the correcting of the mistakes which they will undoubtedly make. But corrections should be made as painlessly and as unobtrusively as possible. Often the best way is to repeat a student's utterance, rephrasing it to demonstrate the correct form, asking perhaps for a repetition. If a student is really floundering for a word, one should give it, letting the student complete the utterance. There may well be occasions, however, when the teacher decides to ignore a mistake completely. At times it is better not to call attention to mistakes in the cause of fluency: to have students over-conscious of the possibility of error is to inhibit their expression.

In each session it is good to ensure that every student gets a chance to

contribute something. The contributions they are invited to make need to be finely tailored to the teacher's awareness of their ability and personality. The shy student can be asked to repeat or read something and be gently urged on to express himself more freely. The confident, sometimes over-confident, student can be given his head rather more and is often a source of humour and fun in the class. The 'know-all' should be gently prevented from dominating the class and making others feel self-conscious. Altogether quite a difficult exercise in human relations for the teacher!

To help the social atmosphere of the class, the teacher can 'break the ice' by first introducing him- or herself, inviting students to follow suit, and by spending a few minutes gaining valuable information – asking them their reasons for wanting to learn French. It is important for the teacher to understand and support the student's motivation.

The way the classroom is arranged can also be a help or a hindrance to success. Formal rows of chairs or desks facing the teacher at the front can be off-putting. Preferable is the circle of chairs or the 'hollow square' so that the teacher is centrally placed as one of the group and no student is hidden and out of eye- or ear-shot and can more easily be drawn into a discussion or activity.

In the teacher's mind should always be the thought that he is almost certainly dealing with a very mixed group of individuals from different backgrounds and of different ages – some may be much older than the teacher. The students will be coming to the class probably in the evening after a day at work and they will probably be paying for the experience. It is not a bad thing for the teacher to feel some humility in this situation.

A very useful source of further practical ideas and guidance to those teaching foreign languages to adults is the book 'Teaching Languages' published by the British Broadcasting Corporation.

Some useful addresses
French Government Tourist Office, 178 Piccadilly, London, W1V 0AL
Food and Wine from France, Nuffield House, 41–46 Piccadilly, London, W1V 9AJ
French Railways, 179 Piccadilly, London, W1V 0BA
French Embassy, 22 Wilton Crescent, London, SW1X 8SB
Syndicats d'Initiative in most French towns will usually send you an information pack on their area, normally without charge.

Basic suggestions

Oral and writing practice

The suggestions below for exercises and activities to exploit further the course with your students are not prescriptive. Many experienced teachers will have their own well-tried ideas and techniques to apply in their teaching with *A vous la France!* For others, however, it may be useful to have a check-list of ideas which can be used regularly, subject, of course, to the need to ensure a degree of variety and novelty in each lesson to sustain students' interest and motivation.

A highly important component of the course is the dialogues which present French people using the social and situational language which the students need to master. Your students will probably have listened to and worked on their own with the radio and/or television dialogues but you will still want to give them further 'face-to-face' practice to reinforce the vocabulary and structures used in that material.

1 The simplest activity, of course, is to give students a role from the dialogue and have them read it out as realistically as possible.

2 Play your chosen dialogue through on a tape recorder, using the pause button to stop the tape suddenly. Warn the class that as soon as it stops they must give you the next word or phrase. They can do it with or without the text in front of them. This will strengthen their concentration and help to get them thinking in phrases and sentences.

3 You can use the above technique without a tape-recorder by simply reading out the passage yourself and stopping where you want to pinpoint a word or phrase. You might occasionally ask a student to read and stop for others to provide the following word.

4 Use the blackboard to familiarise students with a selected text. Write up the dialogue (or part of it) on the board. Invite students to read out the parts in it. Ask the class to close their eyes while you erase some of the words from the text. Ask them to read their roles again, filling in the gaps. You can do this until there is practically nothing left of the text on the board.

5 Read out the selected dialogue but make slight changes in the text which the students must spot and correct. For example in Chapter 1, in Dialogue 1, line ten, you might read out *trois panachés, alors.* Students must stop you and correct to *deux panachés, alors.*

6 Invite groups of students to enact a scene presented in the chapter you are working on, without referring to the text. It adds realism and fun if they can actually pretend to be the people, say, in a café ordering and serving drinks and snacks.

If your class is slow to extend and improvise, you can indicate the direction their dialogue should take by writing up items to be bought or asked for, with the prices, on the board.

You might, for example, give them this very simple situation to play out in groups:
Vous êtes dans un café avec un(e) ami(e). Vous désirez un café et un jus de fruit. Un café coûte trois francs, un jus de fruit cinq francs cinquante.

7 If your class wishes to have an additional 'out of class' assignment, you could suggest that they write out one or two short dialogues based on the topic groups listed above.

8 Ten questions – a regular piece of written practice and revision. Read out ten phrases which the students must write down in French. Select your phrases from material already covered in the course. For example:
last week
by bike
a bit less
how much are the pears?
this one (referring to a vase)
these (referring to tomatoes)
a room with a shower
my German friends
every ten minutes
at the end of the street

9 Use your tape-recorder not just to play dialogues to the students but to record their enactments or readings of dialogues. Play these back for everyone to hear and discuss. The important errors to concentrate on are those which would mean that the student would not be understood. After this discussion and correction, get the students to repeat their performance and show them how and where they have improved.

10 **What would you have said?**
Simply a way of making the course material relevant to the individual needs of students. Take any sentence from one of the week's dialogues and ask students what they would have said if they had been taking part in that particular exchange. For example:
What would they have ordered in the café?
Who is their ideal partner?
What did they do at the weekend?
What countries have they visited?
When do they start and finish work?
What is there to do in their town?

11 **Variations on a single sentence**
Start with a simple sentence or idea which the students must repeat in French. Then alter elements within it so that students are coping with one change at a time or adding one more element to the sentence. For example:
a croissant
four croissants
I'd like four croissants.

I've got four croissants.
Have you got any croissants?
There aren't any croissants.
There aren't any.
There aren't any left.
There aren't any croissants left.
I haven't any croissants left.

12 **Vocabulary reinforcement 1**
Take a dialogue. Ask students to replace a chosen word in the text by as many other words they can think of that would fit the context (eg *un café* might be replaced with *une bière, un panaché, un kir, une limonade, un verre de vin rouge*, etc). This can be made more demanding by removing only a noun and not the article, so gender has to be taken into account in the substitute noun. And it can be done with verbs, adjectives (good agreement practice) and even prepositions (eg in a phrase like *à côté de l'église*, what could stand in place of *à côté de*? Or *à côté*? Or ask them to replace *église*, then *l'église*, then *de l'église*).

13 **Vocabulary reinforcement 2**
Build word categories – this is a variation on the same theme. Get students to compile lists of words under certain categories, eg in unit 1 make a list of things mentioned in this chapter that:
a) you can eat
b) you can visit
c) you can drink
d) are made of paper.

Is there anything that you can both drink and visit? Yes, *un café*. In later chapters, categories can be devised to suit the needs of the week – eg colours, words for relationships, containers, nationalities, things that are free, forms of transport, words for describing personality, professions, things that would fit into a pocket, ways of thanking people, things you might find in a fridge, etc.

14 **Building vocabulary**
The vocabulary in the course is rather restricted. Get students to ask about words that don't appear and that they'd like to know (eg their job, their favourite pastimes, food and drink, their own personality, physical description of their friends, family, spouse, etc).

A final point
Students must recognise that learning a foreign language does involve hard work and a good deal of repetition. You can make the repetition bearable and even fun by varying activities within a lesson and treating many of them as a game. If students can be encouraged to be inventive, to 'let themselves go' a little and be adventurous with the basic situations and materials of the course, they will enjoy their work all the more and learn more quickly and easily.

Vous désirez?

Asking for and buying things

Greeting people and saying goodbye: *bonjour; au revoir*
Saying please and thank you: *s'il vous plaît; merci bien; merci beaucoup; je vous remercie*
Buying and paying for things: *Ça fait combien?; Je vous dois combien?; Combien je vous dois?*
Asking for something: *Vous avez un/une . . .?*
Saying what there is/are: *il y a un/une/des/le/la/les/l' . . .*

Grammar
Definite articles: *le, la, l', les*
Indefinite articles: *un, une, des*
Question form
Some numbers

1 **Breaking the ice**
Start immediately to accustom the students to talk – to you and to each other. In the first session use the greeting *bonjour* to get to know your students and help them to know each other. Ask them to write their name on a piece of folded card or paper which can stand on the desk in front of them. Thus a simple 'ice-breaking' routine can be followed:
You might indicate a student and attribute an incorrect name to him or her, saying:
C'est Madame Smith?
to get the reply from other students:
Non, c'est Monsieur Jones.
For pronunciation practice, get students to greet each other thus:
Bonjour, monsieur/madame/mademoiselle/Henri/Paulette as appropriate.

2 **Number practice**
Quick counting is good practice. You start, for example, by saying *un* then pointing at students in turn who must quickly give you the next number.

You might get them to add or subtract a given number to or from any number you call out.

Call out prices which students must add together and give the total:
un café, trois francs; une orange pressée, quatre francs.
Answer: *sept francs.*

3 **Flashcards**
Using pictures can be an entertaining way of stimulating students to produce language as well as reinforcing vocabulary. Pictures cut from magazines, can be pasted on to the card (some teachers laminate the card to lengthen its life).

Here, for example, pictures illustrating the key words – *cinéma, église, restaurant, théâtre, musée* could be used to practise the use of *il y a*.

One game technique is literally to 'flash' the picture very quickly at the class, allowing a very short time for the response.

Try a 'true or false' game. *C'est un cinéma? – Non, c'est un restaurant.*

4 **Realia**
A useful and 'fun' way to make an enactment of a scene by the students a little more real is to provide objects you have collected – cups, glasses, bottles, maps, plans, containers with labels, etc.

Use a box of objects at the front of the class to provoke questions. Students must ask for what they want: *Vous avez une bouteille de bière, s'il vous plaît? – Oui, voilà une bouteille de bière.* The same procedure is used in reverse after you have given out, or sold, your objects to get them back into the box.

Practise prices again by holding an 'auction' of your objects.

5 **Asking questions**
Give some practice to your students at asking questions. At this stage the simplest form to use is the 'declarative' question – the statement made into a question by using a rising intonation. Ask the students to compare the similar sound pattern of English and French questions:
C'est Monsieur Paccard? It's Mr Paccard?
Tu prends une bière? You want a beer?
Ça fait combien? It's how much?

This calls for some intensive pronunciation and intonation practice. More examples you might use are:
Vous désirez?
Et avec ça, madame?
C'est pour vous, monsieur?
Ce sera tout?
Une bière pression?
Oui, monsieur?
Vous avez un plan de Bourg?
C'est gratuit?
Il y a des cafés?

Reinforce by calling attention to the sound difference between the question and answer using the same form of words:
C'est gratuit? – Oui, c'est gratuit.
C'est bien? – Oui, c'est bien.

6 **Question chain**
Give the students a few minutes to prepare several questions. Choose a student who must put a question to another member of the group. When this person has answered, he or she must put another question to someone else – and so on round the class.

7 **Random dialogue**
Distribute this dialogue which has been scrambled up and ask them, in

pairs, to reassemble it in a meaningful order. Ask them also to give names to the characters who are speaking.

Vous désirez?
Dix francs cinquante, monsieur.
Merci beaucoup, monsieur.
Un jus de fruit, s'il vous plaît.
Messieurs-dames, bonjour.
Ananas, orange, abricot, pamplemousse.
Pression?
Et pour madame?
Bonjour.
Très bien. Tout de suite.
Merci, madame. Je vous dois combien?
Orange, s'il vous plaît.
Une bière, s'il vous plaît.
Voici douze francs. Merci.
Oui, pression.

8 **Reinforcing vocabulary and gender**

Play an anagram game by writing a word on the blackboard, including the definite article, in a scrambled form. Thus, you might write 'clarate'. The first student to give you *la carte* wins the point. If you can prepare your words beforehand on pieces of card or paper, you can cover more key words more quickly.

9 **Rencontres dialogue**

Ask your students to read this through again carefully. Ask a student to imagine that he or she is asked by a French tourist what there is to do in his or her town. You play the tourist to model the exercise before asking them to practise this activity in pairs.

10 **Trouble-shooting**

On a course where students will be listening to, watching and working on the material at home, it is a good idea to have a few minutes in each session when you invite them to ask questions. Students should be encouraged to raise any difficulties with you as soon as they can. Suggest that they keep a note-book and write down any problems they encounter.

2 Où . . . ?

Finding your way around

Asking if something is nearby: *Il y a un/une . . . près d'ici?*
Asking where something is: *Où est . . .?; Où sont . . .?; C'est où sur le plan?*
Getting directions: *à gauche; à droite; sur la/votre gauche/droite; ici; là; là-bas; première/deuxième*, etc; *en face; à côté; au bout*
Asking where someone is from: *Vous êtes d'où?; Vous êtes de Bourg?*
Saying where you are from: *Je suis de . . .; Je suis anglais(e)/ gallois(e)*

Grammar
Verb: *être*
Negative: *ne . . . pas*
Subject pronouns *il* and *elle*
De + le = du
Adjectives of nationality – agreement

1 **Revise**
Keep previous material fresh in your students' minds. Ask pairs of students to enact simple café scenes – ordering and paying for drinks – on which you concentrated in the last session.

2 **The overhead projector**
This is an extremely useful teaching aid. If you have access to one in your classroom, prepare a map showing the features mentioned in the dialogues. You can now give your students practice in giving directions which you can indicate with a pointer on the screen as they give them.

3 **Vocabulary reinforcement**
Give a quick test periodically. Ask your students to write down the twenty words, say, which you are going to call out. As you say the English word, they must write down the French equivalent, spelling it correctly and giving the gender if the word is a noun.

4 **Using pictures or drawings**
Choose ten items of vocabulary – for example, *baguette, tasse, bouteille, croissant, ticket, église*, etc – and show them to your students, asking them to say the appropriate word. When you have gone through the ten words fairly quickly, ask the class to remind you what they were. Start, perhaps, by asking one student for a word, move to the next person who must repeat that word and recall another one – continue round the class until all the words are recalled.

5 **More practice on the dialogues**
Working quickly through the dialogues in turn, make a statement on each one which may be correct or incorrect. The students must confirm a true statement by repeating it or must correct a false one. Make

sure that you introduce *ne . . . pas* and *il* and *elle* in your statements. For example:

From Dialogue 2 you might say: *Il y a une boîte à lettres dans la deuxième rue à gauche.*

From Dialogue 10 you might say: *Le musée? Il est juste en face du Jardin de Ville.*

6 Prepare copies of a simple plan of your students' own town. There should be two sets of your plan – both identical except that only one set will be labelled with the names of buildings and shops. Ask your students to work in pairs, one of them with the complete map, the other with the unlabelled version. Starting from the *point de départ* marked on the map, the student with the blank must ask for and receive directions to all the buildings shown and label them on his plan.

7 **Listening comprehension**
Using the labelled map which you prepared for pair work, tell the class where they are – *Vous êtes à la gare* – and then give instructions which they must follow on their copy of the map. Your last remark should be *Où êtes-vous?* They should have all reached the same place, but check to see if anyone got lost!

8 Ask students to tell you how to get to a particular place in town, starting from the building you are in. Interpose questions – *C'est loin? C'est près d'ici?* Pretend to be a little stupid and repeat their directions wrongly so that they have to correct you.

9 If the lay-out of your classroom permits this safely, play a version of *colin-maillard*. Call for a volunteer to be blind-folded and positioned at the front of the class. The volunteer must now be directed by you (or better by another student) to reach a particular point in the classroom. (Teach the well-known French word *Stop!*)

10 **Pair practice on where people come from**
Prepare on slips of paper lists of information about several fictitious people – their nationality, town of origin, whether they are on holiday or just passing through, how long they are staying, whether they like the area. Give an 'identity sheet' to one student in each pair. The other student should now question his or her partner to obtain all the information on the sheet. All the material they need is contained in the *Rencontres* dialogues.

11 Practise the negative form *ne . . . pas*. Draw up a sentence table on the board:

	ne			
			pas	
	n'			

Ask students in turn to come out and fill in one item in any blank space. If movement is difficult in your classroom ask students to call

out their suggestions. When all the gaps are filled, ask them in turn to read out a correct sentence.

12 Pronouns *il* and *elle* and adjectives of nationality
Point to a student – *C'est bien Madame Smith, n'est-ce pas?* and wait for confirmation or correction from the students. Continue – *Elle est de Paris? Elle est française?* Have the students listen to your intonation as you ask the questions and, of course, to the sound differences between the masculine and feminine forms of the adjectives you use. Conduct this activity fairly briskly.

13 **To help get students talking**
Try to obtain as much colourful, stimulating material as you can – posters, maps, timetables, adverts, etc. If your classroom is secure, pin up pictures on the wall to create a lively atmosphere.

Try, if you can, to have a picture 'of the week' from a magazine about which you can say something to the students and which might stimulate their questions or comments.

3

Combien?

Buying things and asking the price

Asking prices: *C'est combien le kilo/(la) pièce?*
Being told the price: *deux francs (la) pièce/le kilo/la livre/la boîte/les six*
Asking what things are: *C'est un/une/du/de la/de l'/des ...?; Qu'est-ce que c'est?*
Asking for something: *Je voudrais ...; Vous avez du/de la/des/de l' ...?*
Saying how much or how many you want: *trois cents grammes de ...; un litre de ...; un morceau de ...; une tranche de ...*
Talking about the family: *Vous avez des enfants/des filles/des garçons?; Vous avez combien d'enfants?*

Grammar
Partitive article
Verb: *avoir*
Numbers 0–69
Pronoun *en*

1 **A warm-up activity**
Tell your students that they have a few minutes to prepare at least two questions each which they are going to put to you for you to answer.

Point out that they can be drawn from any of the first three chapters of the book and deal with where you are from, your nationality, whether you have children and how many, where a place is and how to get there, the price of things, etc. Challenge them to see how many questions they can get in 'against the clock' – that is, in a given amount of time measured on your watch.

2 **A sentence-building game**
Divide your class into groups (how many will depend on the number of students you have). Ask each group to produce five sentences – they may take them straight from the book or adapt sentences they find there. Each sentence should be clearly printed on a strip of paper – use a different colour for each sentence if you can. The sentence strips are cut up into words and shuffled. The groups should now exchange their 'sentence strips'. The group to assemble all the sentences correctly first is the winner.

3 **Shopping lists**
Prepare shopping lists – all the same – and give one to each student. Do not list the prices of the items. For example:

Prix

un kilo de pommes
une livre de cerises
300 grammes de fraises
une bouteille de vin rouge

17

un litre de lait
une baguette
une douzaine d'oeufs

Choose two or three of your students to be the 'shopkeepers'. Tell them to insert the prices they wish to charge against the items on their lists. The other students can now 'go shopping', asking the shopkeepers if they have certain items and how much they are. Obviously the prices will be different in each 'shop'. Tell your students that they must shop as cheaply as possible, marking the prices of the items on their list and producing a total. When everyone has finished, check who the most careful shoppers are.

4 **Population survey**
Conduct a survey with your students. Draw a simple grid on the board with a line for each student. Ask questions to discover if they are married, how many children they have and of what sex. Then ask what they think the ideal number is and whether they think marriage is important.

	Homme ou Femme	Marié(e)	Nombre d'enfants	Fille(s)	Garçon(s)	Mariage important?	Nombre idéal d'enfants
A	F	Oui	2	1	1	Oui	2
B							
C							
D							

When your grid is complete, you can discuss the results with the class. This gives a good opportunity for further practice of numbers – how many married people there are, the total number of children, etc.

5 **Chain activity**
Choose one student who must begin the chain by saying *Dans mon sac j'ai . . .* followed by an item he might have bought. The next student repeats that and adds one further item of shopping. See how far round the class you can go and how many items you can get into the shopping bag before the chain breaks down.

6 **Cost of living comparison**
If you have access to current prices in France, an interesting task is to compare the cost of living in France and the UK. Base this on a list of basic commodities which your students should help draw up. You can use the rate of currency exchange which is usually quoted in the national daily press.

7 **Checking your bill**
Call out a list of purchased items with their prices. Students must take a quick note of what they are being asked to pay and arrive at a total. The first student to call out the correct total is the winner. If they are confident enough, let students produce a list and call the prices.

8 More number practice
 Write up a series of numbers on the board in figures and in random
 order between 1 and 69. Obviously, the activity will be more difficult
 at this stage if you concentrate on the higher numbers.

 Ask a student to stand at the board. As you or members of the class
 call out numbers, he or she must ring the correct number. Do this
 fairly quickly – when one student 'gets out', another must take his or
 her place.

9 Grammar
 Discuss *des* and the partitive article with your students, after they have
 read the summary again in *En bref*. Give more examples for them to
 consider, perhaps in the form of a table. Ask them to read out correct
 sentences:

Vous avez	de la du de l' des	vin cerises carottes lait pommes huile beurre	s'il vous plaît?

 Part of the discussion might be on the English use of 'some' or 'any' –
 a difficult problem for foreigners. Ask them to think about why you
 can say 'Have you any eggs?' and 'I have some eggs' but not 'I have
 any eggs'.

10 More practice with the partitive and other articles
 There is no reason why you should not teach *j'ai acheté* as a single
 lexical item and ask students to list the things they have bought that
 day and read it out:
 *Aujourd'hui j'ai acheté du lait, des cigarettes, un journal, des pommes,
 un billet dans le bus, de la bière.*

11 Vocabulary practice
 Make up lists of three words. In each set of three there will be an 'odd
 word out'. The students must listen carefully and write down the odd
 word out. Example: *une cerise, une pomme, un concombre.*

12 Comparing cultures
 Discuss shops and shopping in France and the UK with your students.
 Some of them may have experiences to relate from a stay in France.
 Point out the little differences which exist – such as the way a French
 shopper will insist on checking the quality of fresh food, even to the
 extent of squeezing fruit and vegetables, a practice which most British
 shopkeepers would frown upon. Also the way a French shop assistant
 will not usually put your change into your hand as happens in the UK
 but puts it down on the counter.

13 **Shopkeeper language**

Ask your students to consider, and give examples of, shopkeeper language in English. Such phrases as:

Can I help you?

Can I get/show you anything?

Yes, madam?

Are you being served?

This is language which belongs to a very specific situation. Then draw up a list of equivalent 'shop' phrases in French.

14 **A recipe**

Find a simple recipe in a French magazine or cookery book and go through it with your students, making sure that they understand the names of the ingredients. Practise the partitive again by asking *Qu'est-ce qu'il y a dans . . .?* For example:

Qu'est-ce qu'il y a dans une salade niçoise?

Il y a des tomates, du thon, de la salade, du vinaigre, des olives, de l'huile . . . , etc.

Get the students to ask each other similar questions about ingredients in other dishes, perhaps English food:

Qu'est qu'il y a dans une omelette?/dans le Yorkshire pudding?/dans le Toad in the Hole?

4 Qu'est-ce que vous avez comme . . .?

Saying precisely what you need

Asking what is available: *Qu'est-ce que vous avez comme . . .?*
Describing exactly what you want:
 Flavours – *au citron; au jambon; à la vanille*
 Prices – *à dix francs*
 Sizes – *grand, petit*
Asking for a hotel room: *Vous avez une chambre pour deux
 personnes?/pour une nuit?/avec salle de bains?*
Talking about a person's job: *Quel est votre métier?; Je suis ingénieur.*
Talking about what languages someone speaks: *Vous parlez
 (l')anglais?; Je parle bien/un peu . . .*

Grammar
Adjectives – agreement
au, aux
Verb: *faire*
Liaison of consonants and vowels
Est-ce que . . .?
Qu'est-ce que . . .?

1 **Question practice**
Prepare flash-cards of the items occurring in the dialogues: *glace,
sandwich, lait, timbre, carte postale, allumettes*, etc.
Have students question you: *Vous avez . . .? Est-ce que vous avez . . .?*
As you produce the article, make sure that they ask a price (it will be
helpful if you make a note of the price of each article on the back of
the card).

After modelling the activity, get a student to take your place as waiter
or shopkeeper.

After your selected articles have been 'sold' to the students, buy them
all back. If you pay, say, *cinq francs cinquante*, offer a ten-franc note
and get them to say what change they are giving you.

2 **Dialogue building**
Construct a short dialogue based on Dialogue 4. Write each word of
the dialogue on a piece of card. Give a set of cards to each group of
students and ask them to reassemble in a meaningful order your
dialogue 'jigsaw'.

3 **Hotel conversation**
Invite your students in pairs to prepare and perform a conversation in
the hotel – one taking the part of the receptionist, the other a tourist
asking for a room. Tell them to base their dialogue on numbers 5 and
6. If possible, record some of the dialogues as they are performed and
replay them for comment and analysis.

4 Practising of adjectives

Construct a sentence table which you can present on the board or on a stencilled sheet. Include the adjectives met in this and earlier chapters. It might look like this:

Ce vin Les fraises La chambre Madame Dupont Pierre Monsieur Pascal Les glaces italiennes	est sont	délicieuses. bonnes. grande. française. petit. bonne. italien.

Ask your students to make up as many sentences as possible by selecting an item from each column, making sure that they have a match between the items. Afterwards, point to one of the nouns and ask them to suggest other suitable adjectives which are not already in the right-hand box.

NB The distinction between the singular and plural of most adjectives (eg *italien/italiens*) is purely as written and not a phonetic one. So if this exercise is done orally, more permutations are possible.

5 Find the question

Write up on the board a series of answers drawn from Chapter 4. The students must now produce the questions which provoked those answers.

6 Vocabulary reinforcement

Select a number of objects (or pictures of objects) according to the vocabulary you wish to test. Let the students see them all and name each one. Ask them to close their eyes and remove one object from the table. Move the items around and ask the students to look again and name the missing item. Continue until you have removed all the items. See if they can tell you which ten items you started with.

7 Dictation

Practise spelling and adjective agreement by reading out a series of sentences slowly for the students to write down. Read each sentence twice. Examples:

Madame Parry est écossaise.
Elle parle bien l'anglais.
Ce vin rouge est délicieux.
Je voudrais une chambre pour une nuit.
Elle a deux petits garçons et une grande fille.
Donnez-moi une tranche épaisse.
Je viens d'une petite ville française.
Les grands magasins sont en ville.
Le petit déjeuner n'est pas compris.

8 Pronunciation

Give your students some pronunciation practice on the sentences you have used for dictation. One technique is called 'back-building': the

students repeat the sentence a word at a time, beginning at the end of the sentence. For example:

écossaise – est écossaise – Parry est écossaise – Madame Parry est écossaise

The point of starting at the end of the sentence and working backwards until they are saying the complete sentence is to concentrate their attention on the sound of each item and not to distract them too much by worrying about content and meaning.

9 **Silly dialogue**

This is a version of the first part of Dialogue 6. You can either write this out for the students to see and correct or, to make it more difficult, read it out and give them some hard listening practice.

Bonjour, monsieur.

Merci, madame. Est-ce que vous avez une cerise, s'il vous plaît?

Oui, monsieur. Pour combien de personnes?

Pour quinze personnes.

Oui, c'est possible, monsieur. Pour une seule nuit?

Oui, monsieur, pour deux nuits.

10 **Authenticity**

Try to obtain a real hotel brochure and make copies of a page or section of it. Study this with your students, asking them as many questions as possible on the information provided:

C'est un bon hôtel?

Il y a combien de chambres?

Où est l'hôtel?

Quel est le nom de l'hôtel/du propriétaire? etc.

1 This is a point in the course when you should take stock with your students, remind them what they have achieved and also have an extended 'trouble-shooting' session. They may well already have attempted the 'test' in this chapter (*Bon courage*) and this will probably produce some items for discussion and clarification.

2 **About food**
In this chapter the important matter of buying food in France is raised again. You could carry this further with your class by showing them pictures of food and drink from magazines – advertisements make excellent material.

Introduce some of the adjectives which describe food, for example: *frais, doux, sec, délicieux, savoureux, salé, sucré, rôti, cuit, cru, succulent, piquant, poivré, chaud, froid, bon, mauvais, infect.*
Try to use these in questions. For instance:
Voici du vin français. C'est du rouge ou du blanc?
Voici du cidre. C'est du doux ou du brut?

Vocabulary building: get the class to list, in French, the ten products they would take with them if they were marooned on a desert island.

3 **Revise numbers using the game 'Lotto'**
This does involve quite a bit of preparation, but once done you have a number-practising game which you can use again. You might even get your students to help you make up the cards. Mark out squares on pieces of card and print a number in each square. The more numbers you have on the card, the longer the game will last. No card should have exactly the same numbers, of course. Give each student a card and call out at random the numbers you know are covered by the cards. The students should mark off each number they hear which appears on their card. The student who fills his card first and calls 'Lotto' is the winner.

4 **Vocabulary revision**
Using either your stock of flash-cards and pictures or pieces of paper or card on which you have printed a word clearly, challenge your students to produce a sentence which contains the word they see as you hold up each card.

5 In this chapter there are quite a number of words which describe people: *blond, calme, honnête, gentil, intelligent, sérieux, grand, travailleur.* You could add *amusant, sympathique, beau, petit, élégant, bavard,* etc.

 i Use the list to get your students to describe someone in the class. The others must guess to whom they are referring.
 ii Make up on a sheet of paper a questionnaire listing these attributes.

Students must then fill in on their sheet their preferences in their *partenaire idéal*. Then have each one describe that choice to the class. Stress that adjective agreement is important here.

6 Use your overhead projector, if you have one, to show a dialogue on the screen from which you have removed one character's speech. Take Dialogue 6, say, and omit Madame Billat's remarks. Students now take the roles of the *vendeuse* and Madame Billat and complete the dialogue. Encourage the students taking the role of the shopper to introduce different answers from those given in the original text.

7 **Dialogue practice**
Make up a tape to be used on your tape-recorder (or in the language laboratory if you have one) to practise Dialogue 9. Record the text as follows:
Excuse me, madam.
(Pause for student to produce *Pardon, madame*).
Is there a chemist's near here?
(Student: *Il y a une pharmacie près d'ici?*)
Yes, there's one just on the right.
(Student: *Oui, il y en a une juste à droite*).
. . . and so on.
Control the pause so that there is just enough time to produce the French version.

8 **Play questions against the clock**
Give the students time to produce at least two questions each which they can take from any of the previous chapters. They must then fire their questions at you for you to answer just as quickly. Get someone to keep a score of the number of questions the students can get into, say, two minutes.

9 **Pronunciation practice**
A listening exercise. Make up a list of sentences which include *je suis* followed by an adjective. The students must decide and note down whether the speaker would be a man or a woman. For example:
Je suis française.
Je suis étudiant.
Je suis sérieux.
Je suis grande.
Je suis calme (an awkward one this!)

Bon voyage!

Using public transport

Enquiring about times: *Le prochain car est à quelle heure?; Il arrive à quelle heure?; Le dernier car part à quelle heure?; Est-ce qu'il y a des trains le matin pour ...?*

Being told the time: *Il est à huit heures; Il arrive à neuf heures; Il part à 15h15.*

Buying the ticket: *Un aller-retour/un aller simple pour ...; en seconde classe; en première classe*

Asking for other information: *Le train est direct?; La correspondance est à quelle heure?; Le train part de quel quai?*

Saying when: *à dix heures; après neuf heures; la semaine prochaine; tous les samedis; tous les jours; toutes les vingt minutes*

Telling the time: *Quelle heure est-il?; Il est ...*

Days of the week and months of the year

Grammar

Verb forms with *je, il/elle, nous, vous, ils/elles*
Some irregular verbs: *aller, faire, être, avoir*
Formation of adverbs
The infinitive

I **Dialogue practice**

i Give the students practice at reading aloud Dialogue 1. Concentrate on pronunciation, particularly of new items, and their intonation of the questions.

ii With the students' books closed, read selected sentences from the dialogue and stop at certain points. Get students to continue with the next word or phrase. Stop at the new items of vocabulary.

iii Ask students to practise reading in pairs the roles in Dialogue 2 and then to construct a simple 'station dialogue' based on this.

2 **Railway timetable**

On the blackboard (or on a worksheet) make up a table giving information about train departures and arrivals at their destination. It might look like this:

TRAINS EN PARTANCE			
Départ	Destination	Quai	Arrivée
06.00	Paris	2	09.46
09.15	Orléans	6	09.55
11.25	Dieppe	4	13.15
12.30	Marseille	3	17.50
13.45	Lyon	7	21.13
14.22	Marseille	8	20.28
16.18	Caen	2	19.50
17.30	Lille	1	23.07

Now you can question students on their travel plans. For example:

i *Vous allez à Marseille.*
 Vous voulez être là-bas avant six heures.
 Le train part à quelle heure?
 Il arrive à quelle heure exactement?
ii *Le train pour Caen part à quelle heure?*
 Il part de quel quai?
 Il arrive à quelle heure?
 Le train est direct?

. . . and so on. You can do this as an oral exercise or have the students write their answers and read them back to you at the end of a series of such questions. You can adapt your timetable to practise the twelve or twenty-four hour clock, or both.

3 Jouez au dé

If you can find a box with sides of 6″ square or so, print a pronoun clearly on each face: *je, tu, il, nous, vous, elles.* Decide which verb you are going to practise (one of the four irregular verbs listed in *En plus – faire, aller, être, avoir*).

Roll the 'dice' – the students must provide the part of the verb which matches the pronoun which comes uppermost on the dice. Make things a little harder by asking for a sentence which contains the subject and verb.

NB Point out that, as with all verbs, there are more forms to learn in writing than in speech (eg *as/a, fais/fait, es/est* are phonetically identical).

4 More verb practice

A simpler version of the dice activity is to write up pronouns on the board in a random pattern. Announce which verb you are practising and point to a pronoun. The students must give the correct form of the verb with the pronoun (in a sentence perhaps) or write it down to read back to you later.

5 Je pense à quelque chose

A simple way to get students through categories of vocabulary: you (or a selected student) think of something – for example, *une glace.* You say *Je pense à quelque chose qui se mange.* The students must begin guessing what it is by asking for information like: *C'est rouge? C'est petit? C'est gros? C'est un fruit?* and so on. Limit the number of guesses they can have. You can play this as a team game and keep score of the successful guesses to see which team wins.

6

A very simple and effective way of practising telling the time is to make a clock face with hands which can be moved. Set the hands to selected times and get the students to tell the time. Or give the clock to a student, give him a time and see how quickly he can set the clock correctly.

7 More time practice

Dictate a list of times and get the students to write them in figures. After a series of examples, ask them to read the times back to you.

8 Try to get hold of an actual bus or train timetable – a French one would be best, but get a copy of a local one if the real thing is not available. Make copies of all or part of the timetable and ask students questions: *Le car pour ... part à quelle heure? Il arrive à quelle heure?*

9 Invite students to interview each other in pairs about their working day and/or week using the dialogues in the *Rencontres* section as a basis for their questions. Each student should aim at producing a profile of his or her partner's day or week using the *il* or *elle* form.

10 **Holidays**

 i Repeat the interview activity in pairs – finding out about the partner's holiday times and preferences.

 ii Combine the topics of travel and holidays by asking students to play the roles of travel agency clerk and tourist. The clerk will need to obtain information such as when the client wishes to travel, where he/she wishes to go, how he/she wants to travel and the kind of accommodation needed. The clerk can then give the travel information required and book the hotel room(s).

 Invite pairs of students to enact their dialogues for the class and record some examples for comment and analysis.

7

Bon appétit!

Getting a snack or meal

Asking if the café serves food: *(Est-ce que) vous faites à manger?*
Asking what something is: *Qu'est-ce que c'est?*
Saying that you like something, someone: *J'aime ...; J'aime
bien/beaucoup/énormément ...; J'adore ...*
Saying that you do not like something/someone: *Je n'aime pas (du
tout) ...*
Introducing people: *Je vous présente ...*

Grammar
Use of *on*
Familiar form *tu*

1 **Dialogue practice**
 Spot the changes – read out Dialogue 4 but make changes in the text:
 Vous avez décidé?
 Oui, un plateau de tomates.
 Oui, et pour madame?
 ... and so on. Students must call out a correction when you stray from
 the original.

2 Make copies of a menu and get students in groups to practise ordering
 a meal. Suggest that they add character to their dialogue by having
 one of the group be an impatient waiter or waitress, or perhaps one of
 the customers could be indecisive.

3 **Vocabulary reinforcement**
 Basing your list on the *Mots-clés*, write up a number of words on the
 board, some of which contain a slight spelling mistake. For example:
 agnaeu. Students must write down the list and correct the errors.

4 **Listening comprehension**
 Read out a series of questions and answers. In some cases the answer
 will match the question. In others, arrange it so that it does not. Ask
 the students to correct you by giving a matching answer when they
 hear a nonsensical one. For example:
 Vous faites à manger? – Non, que désirez-vous?
 Student reply: *Oui, monsieur. Que désirez-vous?*

5 **Recipe**
 i In almost any French magazine you will find recipes. Pick out and
 copy some of them and distribute them to the students. Give them
 some time to read the recipe through and then ask them to try and tell
 you in English how to make the dish. You can give some help by print-
 ing the meaning of some key words they may not know on the copy of
 the recipe. Or you may use this simple recipe for *la salade niçoise*:
 *Il vous faut: des tomates, de l'huile d'olive, des filets d'anchois, des
 poivrons verts, de l'ail, des olives noires. En plus, des haricots verts,*

des oignons, des pommes de terre, des radis, des oeufs durs coupés en tranches. Coupez les tomates. Coupez les autres légumes en petits morceaux. Ajoutez les oeufs durs. Mélangez le tout. Mettez l'ail et l'huile d'olive. Décorez votre salade avec les filets d'anchois. Servez froid comme hors d'oeuvre.

ii Suggest to your students that they plan a dinner party where the food will be French. They must list the courses, deciding on the entrée, meat, cheese, dessert and, of course, the wine. Compare the different ideas in your groups.

6 **Practise likes and dislikes**
i There are several ways of saying what one likes or dislikes in this chapter. List them on the board. Using pictures of things, or simply naming them, ask students if they like them. For example: *Vous aimez les frites/les glaces/le thé au citron?*
They answer according to their own tastes, for example:
Oui, j'aime ça.
Oui, j'adore les frites.
Non, je préfère les gâteaux.
Non, je n'aime pas ça du tout.
ii Divide the class into two teams. Team A is composed of meat-eaters, team B of fruit-, vegetable- and dessert-eaters. Ask 'rapid-fire' questions to members of each team. If you ask *Tu aimes l'agneau?* of a member of Team A, he must answer that he does like it to get the point. If he makes a mistake, Team B gets the point.

7 **Je vous présente**
Get students to introduce one of the group to the class, saying as much as they can about that person. The rest of the class should ask questions.

8 **Tu and vous**
Discuss the use of these different pronouns in French. Ask the students to consider whether English has any comparable form to *tu* and how it is used. Students in the north of England may well still hear the use of 'thee' and 'thou' ('Where's tha bin'). Consider, too, the ways in which English speakers in different regions of the country use different tags to indicate familiarity:
love, guv, mate, jimmy, duck, flower, hinny, etc.

9 **True or false?**
Make a list of statements – some true, some false. Students must listen carefully to what you say and repeat only the statements which are true. For example: *les Anglais aiment beaucoup le thé; les Français n'aiment pas le vin.*

10 **Proverbs**
The French have a number of proverbs with references to food:
A bon vin, point d'enseigne.
L'appétit vient en mangeant.
Qui vole un oeuf vole un boeuf.
On ne fait pas d'omelette sans casser des oeufs.
Qui dort, dîne.

See if your students, with help, can explain these sayings and ask if they know any English proverbs or sayings which refer to food or drink.

11 **Borrowed words**
 The students have already met a number of English words 'borrowed' into French. Ask if they can list some French words which are used in English. Do people always use them correctly?

12 Compare English and French cuisine with your students. Try in French to decide on national preferences in the UK. Ask students to describe their own favourite meal. You might ask them, for example:
 Qu'est-ce que vous aimez manger pour le déjeuner le dimanche?
 Qu'est-ce que vous aimez manger le soir au restaurant?

Faites votre choix

Shops and shopping

Opening and closing times: *L'Office du Tourisme ouvre à quelle heure?; Vous ouvrez à quelle heure?; Vous êtes ouvert tous les jours?; J'ouvre de dix heures (jusqu')à midi.*
Choosing things: *Je préfère celui-ci/celle-là, etc; Vous avez celui-ci en bleu?; Vous l'avez en bleu?; Vous avez cette robe en rouge?; Je prends la rouge; Je la prends; Le bleu est trop grand; Vous en avez un plus petit?*
Saying what you like doing: *J'aime lire; Je préfère aller au cinéma.*
Saying what are you going to do: *Je vais regarder la télévision.*

Grammar
Verbs with the infinitive: *aller, aimer, préférer*
Comparative of adjectives
Demonstrative pronouns: *celui*
Object pronouns: *le, la, les*

1 **Dialogue practice** – concentrate on Dialogue 4
 i Listen to the dialogue carefully on the tape-recorder and check comprehension.
 ii Have students take the roles of the *buraliste* and Marie-Pierre.
 iii Now tell the students that they are not buying a lighter but a post-card. Ask them to take the first part of the dialogue, as far as line nine, and make the necessary changes.

2 **Dressing up**
 Extend clothing vocabulary slightly, using pictures or with reference to the students' own clothes – *chapeau, robe, manteau, chemise, chaussures, gants, cravate, veste.* Get pairs of students to enact a shop dialogue – asking for things, trying them on and buying them. Practise here *celui-ci* etc and *ce, cette.* Get the 'customers' to vary the role, some to be indecisive, awkward customers who are difficult to please.

3 Ask the students to think of one other person in the room and then ask each one to describe the person they have in mind – what they are wearing and what they look like. Introduce some colours here – *bleu, rouge, noir, vert, gris, jaune, blanc* – as well as the material which clothes could be made of – *coton, nylon, soie, cuir.*

4 **Liking and disliking**
 Using your flash-cards – pictures of clothing, people, food etc, practise statements of likes and dislikes. Show the picture and ask: *Vous aimez cette robe? Vous préférez celle-ci?* and so on. Push the students on to begin using the pronoun and demonstrative form. *Oui, je l'aime beaucoup. Non, je ne l'aime pas. Oui, mais je préfère celle-là.*

5 **Ce que j'aime faire**
 From *Rencontres* 1 and 2, list the several things which people do in

their leisure time – *faire la cuisine, lire, se promener à pied, regarder la télé, aller au cinéma,* etc.
 i Ask the students to list the things they like and do not like doing.
 ii Ask students to interview each other to discover likes and dislikes.

6 **Future intentions**
 Get your students to compile a list of all the things they intend to do:
 i after the class
 ii tomorrow
 iii next weekend

 Round the class get them to state aloud their intentions, using three infinitives under each heading.

7 **Revise ce, cette, etc**
 i Make up a sentence table on the board giving the verb and the forms of the demonstrative adjective:

Subject	Verb	Adjective	Object
	n'aimez pas	ces	
	aime	ce	
	détestes	cette	
	préfère	cet	
	aimons	cette	
	n'aime pas	ces	
	prends	ce	

 Ask students to come out and fill in the gaps with appropriate subjects and objects.
 ii When the table is complete, ask for sentences in which the noun object is replaced by the appropriate pronoun.

8 **Describe and draw**
 Cut out a picture of a man or woman from, say, a fashion magazine. Do not show it to the students, but describe the person – tall, short, man, woman, what they are wearing etc and ask the students to draw a sketch as you describe the picture. Let them ask questions. Finally, ask students to hold up their drawings and show them your picture.

9 **Language awareness**
 There is some discussion in the chapter of colloquialisms with examples in French – *copain, copine, un truc* etc. Consider the use of colloquialisms in English, asking first for the English variations which denote friendships: mate, pal, chum etc. Ask whether other 'titles' like colleague, comrade, brother belong in a particular group or situation. Get the class talking about 'suitability' of particular words for particular situations, and show that French is exactly the same.

Dites-moi

Asking what to do and how to do it

Asking the way to somewhere: *Pour aller à . . .?*; *Comment fait-on pour aller à . . .?*

Asking for something: *Vous avez quelque chose pour . . .?*; *Je voudrais quelque chose pour . . .*

Asking what has to be done: *Qu'est-ce qu'il faut faire pour . . .?*

Saying you play a game: *Je joue au football.*

Saying you take part in a sport: *Je fais du ski.*

Grammar
Il faut with the infinitive
Other forms of instruction: imperative, *défense de*, *prière de*

1 **Dialogue practice**
Using Dialogue 5 as a model, ask your students to prepare in pairs and then perform a conversation in a *pharmacie*. Suggest that they follow the lines of the dialogue but introduce variations. Remind them about the vocabulary of the parts of the body. Ask them also to find alternative expressions for the phrases:
line 4 – *est-ce que vous avez . . .?*
line 8 – *vous voulez . . .?*
line 16 – *merci beaucoup*
　　　　　c'est combien?

2 **Role-play**
Prepare a series of role-play cue cards based on a number of key situations which list the information or the items which the students should obtain. For example, in a hotel.
Roles: a guest and a receptionist. You have arrived in a hotel and you require a room for two people with bathroom for two nights. You also wish to know if the hotel serves food and you certainly wish to take breakfast. Obviously, you will find out what this will cost.
Or in a chemist's.
Roles: a customer and the chemist. You have overdone the sunbathing – your face and arms are very red. Ask the chemist for something to treat this and get clear instructions on how to use the medication.

3 **Etes-vous sportif?**
Conduct a survey with your students to find out whether they take part in any sporting activity, whether they do it or watch it and when and where they do it. Try to practise negatives during this discussion.
Je n'aime pas . . .
Vous n'aimez pas . . .
Je ne fais pas . . .
Vous ne faites pas . . .
Il/elle ne fait pas . . .

4 **A mime game**
 Ask the students in turn to mime an action for the rest of the class.
 They could be putting on an item of clothing, playing a sport, opening
 a bottle and drinking a glass of wine, getting into and starting a car
 and so on. The others must guess and say what activity is being
 mimed.

5 **Language awareness**
 Discuss with your class some of the differences between English and
 French verb forms. For example, a problem sometimes is for students
 to realise that *il joue* can be the equivalent of 'he plays', 'he is playing'
 and 'he does play'. Ask them to consider how English speakers use
 these forms of the present tense in different circumstances.

6 **Giving instructions**
 Practise *il faut* by asking students to tell you what you must do in
 certain situations. For example:
 Pour aller à la gare, qu'est-ce qu'il faut faire?
 Pour faire une omelette, qu'est-ce qu'il faut faire?
 Pour faire une tasse de café, qu'est-ce qu'il faut faire?
 Pour faire une salade, qu'est-ce qu'il faut faire?
 Pour conduire une voiture, qu'est-ce qu'il faut faire?

7 **More use of il faut**
 Read Dialogue 4 again with your students. Then, from line 3, ask
 them to rephrase the instructions given by the *employé* to Bernard.
 For example, instead of *vous tournez* they should say *il faut tourner*,
 and so on.

8 **Vocabulary practice**
 See if you can find pictures from magazines of people playing the
 games and activities mentioned in this chapter. Mount them on card
 for easy use and very quickly indeed show the picture to the class.
 They must call out what is happening: *il/elle fait du ski* etc.

9 **Driving in France**
 Discuss the differences in law and habit between driving in France and
 the UK. Ask students whether they have any interesting or funny expe-
 riences to relate. Make a list of words and phrases used for forbidding
 certain activities, for example:
 Défense de fumer.
 Défense de tourner à droite.
 Il est interdit de klaxonner.

 You could then show a selection of the more common road and other
 public signs and invite them to say, in French, what one should not do
 eg *marcher sur les pelouses/stationner/dépasser/tourner à gauche/
 traverser la voie/se pencher au dehors.*

10

Faisons le point 2

Revision 2

The revision dialogues in this chapter deal with:
shop opening hours and days of the week;
enquiring about what's on;
using public transport;
shopping for clothes and food;
ordering a meal or snack

1 **Taking stock**
Spend some time talking with your students, encouraging them to tell you if they are having any learning problems. Find out if there is some point in previous chapters they would like to return to for more practice.

2 **Revising dialogues**
Use your 'role-play' cards to get students working in pairs practising the key situations introduced so far. Record some of them and play back for comment and advice.

3 **A kiss is just a kiss!**
The *Rencontres* dialogue deals with the French custom of *la bise*. Invite some cultural comparison – do British men and/or women do this? If they do, to whom do they do it? Does it depend on social level?

Discuss also the other very common French custom of shaking hands each time you meet someone. How does this compare with British custom? Are the British a 'stand-offish' race, not given to any display of emotion?

Discuss the way French people address each other, even complete strangers, as a matter of courtesy. For example, entering a shop most French people would greet the customers already there – *Messieurs-dames*, and take their leave – *Au revoir, messieurs-dames*. The habit of wishing people *bon appétit* in a restaurant is also very un-British.

4 **Revise days of the week and months of the year**
Try and use an actual calendar – the desk-top variety is best, which 'flips over' and shows day and month. Show the days at random and ask for a statement of the date. Ask students to tell you one particular thing they do on a particular day at a particular time.

5 **Time and travel**
On paper, draw up a railway departure board giving full train inform-ation. Give this to one or two students who will be the information clerks. The others must decide on a destination and check departure and arrival times, if they are to change, if there is food on the train and how much the journey will cost.

6 **Vocabulary revision**
The students should now have a fairly wide range of questions they

can ask about people and things. Play 'twenty questions' – think of a person or object which you know is familiar to the students and allow them twenty questions to discover what it is. Give them clues if you need to – *j'aime en manger au restaurant; j'en achète à la boulangerie.*

7 **French music and art**
Try to find out what your students' interests are. It may be that one or two of them can introduce a picture or a short piece of music to the class.

You might yourself introduce them to some French music – folk songs or more modern songs such as those written and sung by Maxime le Forestier which are tuneful and written in simple language.

One way to present a song is to give out copies of the words, missing out the vocabulary which the students will know, and ask them to listen hard and complete the transcription.

8 **Listening comprehension**
To encourage students by showing how far they have come, play them on record or cassette some of the very early dialogues. Check comprehension by simple questions of fact.

9 **Cheese and wine**
Try to give some background to Dialogue 8 by showing the students labels from different bottles of wine. A good deal of information is often contained on a wine label and can produce useful discussion.
C'est un bon vin?
C'est un vin français ou allemand?
Il vient d'où?
C'est un vin de cette année?
Tasting it of course leads you to the use of the flavour vocabulary. Wrappings and other foods can also lead to useful discussion.

10 **Revise leisure and sports activities**
 i Discuss students' preferences:
walking – where they go, who they go with, what they wear etc;
reading – what they read;
football – do they play or watch, their favourite team etc.
 ii See if someone has an interesting or unusual hobby which they can try to describe for the others to guess what they do.
 iii Find an advert for a football match (or other sporting event), copy it and ask students questions on the information it contains. A French one would be ideal, of course, but an English one will work. Ask about the time the event starts, where it is held, names of those involved etc. You can also use an advert for a film in the cinema – perhaps easier to obtain in French from a newspaper.

Possibilités

Asking if something can be done

Asking if something is possible: *On peut passer ce soir?; Il est possible de réserver des places?*

Asking if you can do something: *(Est-ce que) je peux téléphoner d'ici?; Est-ce que je pourrais voir la chambre?*

Asking someone if they can do something for you: *Vous pouvez nettoyer cette jupe?; Vous pourriez regarder/me faire une facture/me donner l'indicatif?*

Inviting someone to do something: *Voulez-vous téléphoner demain?*

Grammar
Verbs: *pouvoir* and *vouloir* with the infinitive
Object pronoun: *vous/me*

1 **Dialogue practice**
Concentrate on Dialogue 3 (*Accueil de France*) and after reading this through again with your students, write it up on the board. Have them close their eyes and rub out all the verbs. Now ask students to take the roles of Sara and the *hôtesse* and read aloud, filling in the gaps. Now erase all the nouns and repeat the exercise.

2 **Vouloir and pouvoir**
Write up on the board two lists of sentences – questions and answers – using these two verbs. Ask the students to match each question with an appropriate answer. For example:
 i *Vous les voulez pour quand?*
 Tu peux passer cet après-midi?
 On peut téléphoner d'ici?
 Je pourrais le voir demain?
 ii *Oui, je peux venir vers trois heures.*
 Oui, si vous voulez venir à onze heures.
 Je les voudrais pour demain matin, s'il vous plaît.
 Oui, vous avez l'appareil là.

3 **Question chain**
Ask each student to prepare a question using *vouloir* or *pouvoir*. Each student must then put a question to another member of the class who will answer and put his or her question to someone else.

4 **Making a phone call**
 i Make sure that the students understand how to make a phone call in France. Ask them to tell you how they would make a call from a phone-box, from a post-office or from a café.
 ii If you have access to a language laboratory, this can be quite realistic: give students a situation – ringing up a doctor to make an appointment, ringing a friend to invite them to dinner, ringing a hotel to book a room, ringing a garage to ask for assistance – and when they have prepared their requests, tell them to 'call' you.

In the classroom, this activity is less realistic. The main thing is that students should be talking without seeing each other – you could ask pairs to do this sitting back to back.

5 **Number practice**
 Tell the students that you are going to give them a series of telephone numbers (as in Dialogue 5). Read them out as the *serveuse* does: *Vous faites le seize, puis le cinquante-deux, et puis le onze, vingt-trois, soixante-neuf.* Students must write them down in order. Check at the end of the series that they all 'got through' to the right number.

6 **More extensive reading**
 Using authentic French travel brochures, folders from *Syndicats d'Initiative* etc, prepare some simple reading cards for your students. You can make up quite an attractive display using text and pictures. Allow some minutes of silent reading and then invite some of the students to try and tell the class something about what they have read.

7 **Vocabulary practice**
 Ask each student to make up a list comprising two columns of related words. For example:

 | | |
 |---|---|
 | *vin* | *monnaie* |
 | *train* | *week-end* |
 | *franc* | *bouteille* |
 | *dimanche* | *quai* |

 Ask them to exchange their lists and match up the pairs of connected words.

8 **Language awareness**
 Continue the discussion of 'can', 'could' and 'would'. Ask the students to consider the value of 'could' in sentences like 'I could tell him but I won't', 'I could see him playing' and 'would' in 'Would you help me?' (is this different from 'Could you help me?'?), 'I would help him if I could', 'Each day they would go to church'.

9 **High days and holidays**
 Just as in Pézenas, many British towns and villages have festivals and special events on particular days of the year. Draw up a list of words to do with fêtes and festivals (eg *manège, buvette, stand de tir, concours de beauté, course en sac, musique, majorettes, défilés ...*). Ask your students about their locality, and, as far as they can, get them to tell you what happens and when, and what part they play in the proceedings. For example:
 Est-ce qu'il y a une fête dans votre ville/village?
 Quand? En été?
 Qu'est-ce qu'on y fait? On peut danser?
 Et vous, qu'est-ce que vous faites?
 Vous préparez un pique-nique?
 Qu'est-ce vous mangez/buvez?
 Qu'est-ce que vous achetez?
 Il y a de la musique?

12

Tout sur vous 1

Telling people what you've done

Asking people what they've done: *Qu'est-ce que vous avez fait?*
Saying what you have done: *J'ai mangé au restaurant; J'ai fait du ski.*
Saying you haven't done something: *Je n'ai pas trouvé mon passeport;
 Il n'a jamais visité Paris.*
Saying something has been going on for some time: *J'habite à Bourg
 depuis deux ans; Il y a deux ans que j'habite Bourg.*
Asking how long someone has been doing something: *Vous êtes marié
 depuis combien de temps?*
Saying how old someone/something is: *J'ai/il a/elle a trente ans.*
Talking about the weather: *Il fait beau; Il a fait mauvais.*

Grammar
Perfect tense with *avoir*
Use of *depuis* with the present tense

1 **The perfect tense**
 Go over the explanation of this tense with your students, making sure
 that they understand the fact that several English forms – buy, have
 bought, did buy – are embraced by the French tense *a acheté*. Look at
 more examples of the regular past participle and its formation, *-er* to *-é*.

 You might extend the discussion to consider the different circum-
 stances in English which affect the speaker's choice between ate, did
 eat and has eaten, for example.

2 **Dialogue practice**
 Go through Dialogue 1 indicating the verbs which are in the perfect
 tense. Now ask your students to imagine that Sara and the girl are
 discussing someone else, first a man and then a woman. Get them to
 read out the dialogue making the necessary changes – for example, in
 line 1, *Qu'est-ce qu'il a fait pendant le week-end?*

3 **Vous avez . . .?**
 Ask each student to prepare questions beginning *Vous avez . . .?*
 Vous avez fait du ski cette année?
 Vous avez mangé au restaurant hier soir?
 Vous avez acheté du pain aujourd'hui?
 Vous avez joué au football samedi après-midi?
 Vous avez fait de la planche à voile cet été?

 Each student must then ask his or her partner the questions which
 should be answered in the negative: *Non, je n'ai pas . . .*

4 **Conversation practice**
 In pairs ask the students to question each other closely on what they
 did on a particular day in the recent past. Remind them of the verbs
 *mettre (mis), ouvrir (ouvert), lire (lu), vouloir (voulu), prendre (pris),
 voir (vu), boire (bu)* and suggest that they include some of them. After

pair practice, ask students to give an account of their partner's day, using the third person.

5 **Poem**

An excellent poem to read with your class at this point is *Déjeuner du matin* by Jacques Prévert. Apart from understanding and enjoying the poem, ask students to read it aloud. Although it is a simple piece, there is no punctuation, which offers quite a challenge to the reader. Ask students to describe how they made their tea or coffee that morning.

6 **Slide show**

Dig out some of your slides that you must have taken on one of your trips to France. Give your students a slide show and talk about where you went and what you did – encourage their questions.

Invite students to bring along a few of their slides of a holiday and tell you how they spent their time. During this activity, restrict the use of the perfect tense with *être* as much as possible – *je suis allé(e)* is inevitable, of course, but otherwise stay with *avoir* verbs.

7 **Picture game**

Use pictures to remind students of previously learnt vocabulary. As you hold up a picture, a student must produce a sentence in the perfect tense, using the item shown. For example: showing a picture of fruit – *J'ai mangé des cerises.* A box of matches – *J'ai acheté une boîte d'allumettes.* Reinforce the points by turning the question back to the class occasionally – *Qu'est-ce qu'il/elle a fait?*

8 **Time travel**

Give students a list of sentences which will test their understanding of past, present and future using *aller* + infinitive. Examples:
Hier j'(acheter) une jupe bleue.
Je (aller) au marché dans dix minutes.
Demain j' (manger) au restaurant.

They must write or say the sentences completing the verb in the appropriate tense.

9 **What's been going on?**

Discuss the use of *depuis*. Some of your students may find this idea quite difficult. Ask each of them to prepare and then tell you five things, say, which they have been doing for some time. Examples:
... living or working in a place ... being married to someone
... driving a car ... learning French
... playing a sport ... waiting for the bus

10 **Language awareness**

Invite your students to consider how people speak. Spontaneous speech is full of hesitations, false starts, redundant words and phrases and repetitions. Find, if you can, a recording of some spontaneous speech, or record one of the students talking. Ask your students to listen and comment on the sample. They could transcribe it literally with all its 'faults' and then produce a 'clean' version with all the faults corrected.

13

Saying where you have been

Saying where you've been: *Je suis allé(e) à Paris.*
Saying where you were born: *Je suis né(e) à Bourges.*
Saying you know a place: *Je connais assez bien la Bretagne.*

Grammar
Verbs: perfect tense with *être*
 reflexive verbs
Pronoun *y*
Possessive adjective: *mon, ma, mes* etc
Negative forms: *ne ... que, ne ... rien*

1 **Grammar**
You may well need to examine further with your students the intro-
duction in this chapter of verbs which take *être* in the perfect tense.
 i The question of the agreement of the past participle – *elle est allée*
– is perhaps not one to make a great deal of fuss about at this stage. In
spoken French the additional 'e' or 's' with most past participles make
absolutely no difference to the sound of the word. It may be worth
pointing this out again.
 ii More important is to ensure that students do learn to use the cor-
rect auxiliary verb.
 iii Check that the students have followed the discussion of reflexive
verbs, particularly the past tense with verbs such as *regarder – j'ai
regardé* but *je me suis regardé(e).*

2 **Where did they go and what did they do?**
Question the students on the characters' activities and background in
Dialogues 1, 2 and 3. Ask them to read each dialogue again silently
and see if, after each one, they can answer simple questions of fact
from memory. Example:
*Marie-Agnès, qu'est-ce qu'elle a fait pendant les grandes vacances?
Est-ce qu'elle s'est beaucoup baignée?*

3 **Personal interviews**
Taking the questions used in Dialogues 1, 2 and 3 as a base, ask
students to prepare and carry out in pairs two short interviews with
each other.
 i Ask them to find out about a recent holiday or day out – where
their partner went and what they saw and did.
 ii Ask them to find out more about their partner's past – where they
were born, when they got married, what job they did and so on.

4 **Getting more perfect in the Perfect**
Prepare on the board, or on a stencil, a table to practise the perfect
tense. (Here agreement will matter).
Ask your class to work in pairs and write down as many sentences
from the table as they can in a specified time.

Marie		allé	à Paris à cinq heures.
Je	sont	sortie	quinze jours avec sa sœur.
Ils	est	parti	à Paris, monsieur?
Vous	suis	arrivée	à Bourges.
André	êtes	nés	du café sans payer.
Agnès		resté	vers cinq heures.

5 **Vocabulary practice**
Prepare sets of cards and on each card write down a word. Give one
student in each group a number of cards. He or she must choose one
without showing the others what is written on it.
i By asking the card-holder questions, the group must find out what
is written on the card.
ii Now the card-holder's task is to get someone in the group to say the
word or phrase which is written on the card he or she selects. If, for
example, the card shows *du pain*, he might start by asking *Qu'est-ce
que vous avez mangé aujourd'hui?* – this will signal to the group that
the object is a food. To produce a quick answer, the card-holder might
say *Vous en achetez chez le boulanger*. The point of the exercise is to
give students, who take turns in selecting a card, practice in asking
questions and the rest in producing appropriate answers.

6 **True or false**
Write out the beginnings of several sentences in the perfect tense:
J'ai regardé . . . *Je suis né(e) . . .*
Je suis allé(e) . . . *J'ai acheté . . .*
Je me suis baigné(e) . . . *Je me suis marié(e) . . .*
J'ai visité . . . *J'ai mangé . . .*

Students must complete each sentence; some of their answers will be
true, some false. As they read out their sentences in turn, the others
must accept or reject what they say with *c'est vrai* or *c'est faux* or *ça
n'est pas vrai*, depending on whether they think the person is telling
the truth or not.

7 **Mime an action**
Give each student a card or slip of paper on which you have written a
description of an action: *manger une glace; mettre un pantalon; se
laver les dents; faire une tasse de café; ouvrir une bouteille de vin*. Ask
them in turn to perform their mime. *Qu'est-ce qu'il/elle a fait?* The
others must tell you what he or she has done.

8 **Molière**
With a good group, select a short extract from one of Molière's plays
that you know well, and read this with them. Pick an amusing extract
and discuss the language and humour with them. Your students might
like to act out a piece of real theatre with you.

9 **Language awareness**
Discuss the question of 'received pronunciation' in English – what
some people sometimes call 'BBC English' or the 'Queen's English'.
Do they have this accent? How is it recognised, what do people mean
when they say of someone 'She talks posh'?

14 C'était comme ça

Saying how things were or used to be

Saying how things were: *Nous habitions Nantes; Quand j'étais jeune; Les dangers étaient grands.*
Saying what used to happen: *Ils traversaient l'Atlantique.*

Grammar
The imperfect tense

1 **The imperfect tense**
Check your students' understanding of the formation of this tense and the pronunciation of the endings. Select a number of verbs which the students have met and as you call out the infinitive, get the students to give you the *nous* form of the present tense. Then point quickly to a student who must produce the *je* form of the imperfect tense of that verb. With a good class ask them not just to give you the verb but to try and give you a whole sentence.

2 **Language awareness**
i Sharpen your students' perception of tense and meaning by asking them to comment on these two sentences:
I saw him this afternoon. I have seen him this afternoon.
Ask them to think about the relationship between the seeing and the time of day that these two sentences might have been uttered.
Consider whether the difference between these sentences would occur in French.
ii What slightly different interpretations could be given to each of these sentences:
He went to church at eight o'clock.
She tried to be a good friend.
They drove a red car.

Ask them what words or phrases they might add to these sentences to make it clear whether or not the action was repetitive.

3 **Perfect and imperfect tense**
i Put up on the board a number of sentence 'starts'. For example:
Quand j'étais jeune . . .
Quand j'habitais à la campagne . . .
Quand j'étais en vacances . . .

Ask your students to think of a state of affairs that existed and complete each sentence with a second verb in the imperfect.
ii Write up a number of imperfect tense verbs and ask students to complete the sentence with a perfect.
Je lisais mon journal quand . . .
J'achetais mes légumes au marché quand . . .
J'étais à La Rochelle quand . . .

4　**Then and now**
Try to obtain some old pictures of your town, showing people, vehicles, buildings, etc. Let the students study them for a while and then discuss how things were and what changes have occurred.

5　**Pair practice**
Ask students to question each other on where they used to live, work, things they used to do, friends they used to have and so on.

6　**Alibi game**
Tell some of your students that they are suspects in a major crime – a murder, say! The act was committed the previous evening between eight and twelve o'clock. Give the 'suspects' a little time to consider their alibi and then, helped by the other students, 'interrogate' them on where they were and what they were doing, whether anyone else saw them and so on. At the end, take a vote on the most likely suspect!

7　Prepare a number of sentences giving only the infinitive. The students must give you the completed sentence in the past tense. The clue to which tense to use will be in the adverb or expression of time.
Examples:
D'habitude, il (faire) ses courses le matin.
Hier, elle (aller) à Paris.
Au dix-huitième siècle Nantes (vendre) toujours du sel.
Je (vendre) ma voiture ce matin.
Nous (se lever) tous les jours à sept heures.

8　**Un peu d'histoire**
Give students information from a local guide book about their town's past. Ask them in groups to prepare a very short talk on the town as Claude does in Dialogue 1.

9　**Dialogue practice**
Play Dialogue 1 straight through again on your tape-recorder. Ask the students to follow the text in the book as you do so. Play the dialogue a second time, without the books, using the pause button to stop the tape and asking students to give you the next word or phrase.

10　**Something to remember**
Ask students to prepare a short account of an event or occasion in the past which they remember well – a visit to friends, an accident, a funny incident etc. Listen to a number of these accounts and encourage the rest of the class to ask questions.

11　**Town guide**
Invite each group of students to imagine that they are to give a short introductory talk to visitors from France to their town or village. Suggest that they describe where it is, what there is to see, and so on. Listen to their descriptions and ask more questions.

Revision

1 **Trouble-shooting**
This may be your last chance to go over again problems which the students may be worried about. Ask each student to write down briefly on a piece of paper the point which he or she has found most difficult to cope with – it may be a tense, pronouns, negatives, verb endings or, as sometimes happens, a misunderstanding of some relatively minor point which is causing undue confusion. Look through them at a point in your lesson when the students are engaged in pair or group work and try to deal with the commonest problems.

2 **Bonnes vacances!**
Suggest that the students work in pairs on a short letter to a tourist office in a part of France where they would like to spend some time in summer. Ask them to read out their letters in which they ask for information on the town or area, hotels etc. Addressing their letters to the *Syndicat d'Initiative* (or *Office du Tourisme*) followed by the name of the chosen town and *département* should produce a reply and provide a pleasant reminder of the course, as well as some interesting material for the students to read.

3 **Language awareness**
i Take up this question of minority, regional languages with your students. Are they aware of examples in the UK? (Welsh, Gaelic and immigrant languages from the Indian sub-continent). Should speakers of these languages be helped and encouraged to maintain their mother tongue and the culture attached to it?
ii Apply the question of language variation to the students' own area. Is there a marked local accent, differences in vocabulary or grammar (for example, in York 'I aren't' is a common feature of local speech). Are there regional accents in the UK which are more esteemed than others?

4 **Je vous remercie!**
Ask the students to imagine that they have spent a short holiday with French friends. They must prepare a thank-you letter showing their appreciation for the trouble taken, saying especially what they liked – a visit, a meal, a theatre trip. Suggest that they include an invitation to their friends to visit them in return.

5 **Negatives**
Revise the negative forms – *ne ... pas, ne ... rien, ne ... jamais, ne ... personne*. Ask a series of questions which the students must answer in the negative. For example:
Vous êtes allé au cinéma hier soir?
Il y a quelqu'un à la porte?
Qu'est-ce que vous avez acheté ce matin?
Vous êtes déjà allé(e) à La Rochelle?

6 **Practice makes perfect**

Ask students in pairs to prepare more sentences with the perfect tense (as in *Bon courage* part 3 no 1) giving multiple choice alternatives. The pairs exchange their sentences and complete them in a given time.

7 **L'affaire du Larzac**

Give your students time to read the account of this event silently. Pretend that you know nothing about what happened and ask them to give you an account of what transpired. Ask questions to get them to be precise and clarify details of what took place.

8 **Vive la différence!**

On a number of topics – travel, shopping, food, drink, clothes etc – discuss with your students what they have learnt about France. Ask them to speak about the similarities or differences which they have observed between France and the UK. Encourage anecdotes: *Quand j'étais en France . . .*

9 **Qu'est-ce que vous allez faire?**

Revise the use of *aller* with the infinitive. Ask students to prepare a short description of their plans for the coming summer – if they plan to go away, where, how they will travel, with whom, where they will stay and so on. As individuals give their account of their plans, encourage questions from other students.

10 **Elle a vraiment dit cela?**

Practise comprehension of the dialogues in this chapter by choosing a number of statements made by the characters involved. Tell the class what you believe they said – you may be right or wrong and ask them to confirm or correct your statement. For example, from Dialogue 1 you might say:
Sara a dit qu'elle voulait son pantalon pour ce soir.
or from Dialogue 2:
Martine a dit que La Rochelle n'était pas une ville très agréable.

11 **Read and tell**

Prepare more 'reading-cards', this time more difficult, using extracts from the text and illustration of travel brochures, magazine articles, adverts etc. Students should read the cards in pairs discussing what they read and then give an account to the class of their reading.